IMAGES
of America

PORTSMOUTH
VIRGINIA

IMAGES
of America

PORTSMOUTH
VIRGINIA

Dr. Robert Brooke Albertson

ARCADIA
PUBLISHING

Published by Arcadia Publishing
Charleston, South Carolina

Printed in the United States of America

Library of Congress Catalog Card Number: 2002107722

For all general information contact Arcadia Publishing at:
Telephone 843-853-2070
Fax 843-853-0044
E-mail sales@arcadiapublishing.com
For customer service and orders:
Toll-Free 1-888-313-2665

Visit us on the Internet at www.arcadiapublishing.com

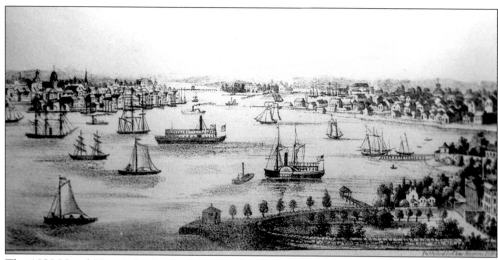

The 1830 Naval Hospital is in the foreground with the town of Portsmouth behind it at right. Notice the powder magazine at the tip of Hospital Point where Lord Dunmore fled in 1776 and where Fort Nelson once stood; a side-wheeler steamboat is shown as well. The growth of steamboat service since 1815, along with the growing of Portsmouth's railroad since 1834, had certainly helped quadruple the population from 2,080 in 1810 to 8,626 at the time of this scene around 1850. (Courtesy Portsmouth Naval Shipyard Museum.)

CONTENTS

ACKNOWLEDGMENTS

There are so many people who have helped to make this book possible. Sue Burton, Portsmouth's Librarian, suggested it to me. Barnabus W. Baker, Historian of the library's Wilson Room and a former mayor of the city, helped me to identify people and to place events in context. Stephen Little, Digital Archivist for the Virginia State Library, helped me both find and submit appropriate images. Rare resources were lent to me by Al Cutchin, Command Historian for the Naval Medical Center Portsmouth, which I have often called simply the Naval Hospital. Alice Hanes, Curator of the Portsmouth Naval Shipyard Museum, provided me with important material and help. I am indebted to her for permission to use images from the museum's collection and to Ms. Burton for letting me use the images from the Portsmouth Public Library's archives. June Brooks of the Portsmouth Planning Department was a great help.

Olde Towne residents have been especially kind. Katrina and Ken Pritchard were enthusiastic assistants who helped me scan important new material. Former librarian Dean Burgess discussed pictures with me and directed me to a useful entry he wrote for the *Dictionary of Virginia Biography*. Gloria Kolodzies and Duane Craps quickly brought valuable resources to me as soon as they heard of the project. Jeanne Larcombe directed me to a collection of rare photographs, and Les French put me in touch with the family of Mike Williams.

Mike Williams was an award-winning photographer for the *Virginian-Pilot and Ledger-Star* newspaper, and his pictures did much to capture the spirit of the recent past. I am indebted to his family for permission to use them. I am also grateful to David Hollingsworth, director of the *Virginian-Pilot and Ledger Star*'s Photo Department for allowing me to use these and other photographs from the newspaper's files.

Ms. Marge Albright of the Portsmouth Redevelopment and Housing Authority helped me with dates and events. J. Robert Burnell gave permission to use two of his prints, and Betty Jo Gwaltney of The Portsmouth Partnership also assisted me by allowing use of one of his prints.

My wife, Lorraine Albertson, has contributed greatly to the writing of this volume with wise counsel and editing. Without her understanding and support, it would have been impossible to have completed this book in time for Portsmouth's 250th anniversary celebration.

The value of Marshall W. Butt's *Portsmouth Under Four Flags* (printed in 1961 and revised a decade later) as well as of his history of the Navy Yard could not be underestimated. The pictorial history of Portsmouth by Robert W. Wentz Jr. (1975) and especially the one by Alf and Ramona Mapp (1990) were invaluable. Abstracts of local newspapers prepared by John Cloyd Emmerson were a great help, and I found many interesting facts in Richard Holcomb's 1930 book, *A Century with Norfolk Naval Hospital, 1830–1930*. I often consulted "Olde Towne Historic District and High Street Corridor Historic District of Portsmouth, Virginia," an architectural survey done by Kimble A. David for the Virginia Department of Historic Resources in 1999. Newspaper articles on local history by Shirley Winters, Chris Gwin, Ida Kay Jordan, and Alan B. Flanders have been most useful. Anyone researching Portsmouth history will certainly want to consult Mr. Flanders's weekly "Olde Towne Journal" column as well the book he authored and the one he co-authored about the Battle of the Ironclads.

To obtain large, high-quality prints of images credited to the Portsmouth Public Library, you may write to http://www.olde-towne.net/friendsofppl. Alternatively, you can reach the Friends of the Public Library through the library at 601 Court Street, Portsmouth, Virginia 23704. If you have photographs, postcards, letters, or other material that should be preserved, please contact the library at the above address. Your material can be copied and returned to you safely and speedily, and you can help save Portsmouth's rich heritage for others to enjoy.

INTRODUCTION

Wouldn't Col. William Crawford be proud to see what has become of the little town he founded in 1752? Though 250 years have passed, Crawford's original vision is still to be found in the name, streets, and ferries of what is now a modern city with a fascinating past.

Crawford named his town for England's famous port, and for over two centuries Portsmouth, Virginia has been creating its own impressive nautical heritage. Its Naval Shipyard has built vessels that changed the course of history, and its Naval Hospital has treated the ill and injured since 1830.

Crawford designed a large central avenue that was extremely wide for the little settlement that he created amid the wooded acres of colonial Virginia. High Street is still the major thoroughfare, and it now accommodates four lanes of modern traffic quite easily thanks to the vision of its founding father.

William Crawford, who also spelled his last name as Craford or Crafford, was a man of distinction in the 18th-century district of colonial Virginia known as Norfolk County. He was a ship owner, a merchant, a member of the House of Burgesses, and presiding justice of the Norfolk County Court later in life. It was that court which on December 20, 1712 had ordered "That Capt. William Craford keep the ferry on his side of the river and that he cause all persons to be ferried over as shall have occasion to pass from his shore," so it is no wonder that Crawford drew a plan 40 years later which included an area for ferry service. Though the docking places have changed, the return of ferry service since 1983 once again has restored this link to Portsmouth's original design as well as its designer.

Portsmouth's progress in realizing Crawford's dream was noted a century ago in Col. William H. Stewart's 1902 *History of Norfolk County, Virginia, and Representative Citizens*: "On the Southern Branch of the broad and beautiful Elizabeth River, 106 miles from the State Capital, Richmond, 230 miles from the Federal Capital, Washington, and eight miles from Hampton Roads, in Latitude 36 degrees, 50 minutes north and Longitude 76 degrees 19 minutes west, lies the city of Portsmouth, in the state of Virginia . . . Nature has endowed her with every physical advantage that can conduce to the growth of a community and the prosperity of a people, enjoying as she does, the delight of a climate at once so mild and healthful that deaths from sunstroke are almost unknown, and from extraordinary exposures to cold even in extreme winter of the rarest occurrence. Blessed with the benefits, in common with her sisters Norfolk and Berkley, of the finest harbor on the American shores of the Atlantic Ocean, possessing the profits accruing from the fertile lands by which she is surrounded; withal peopled by industrious inhabitants, she is moving forward to reach those great proportions her founder, Col. William Craford, expected."

Perhaps even Colonel Crawford, though, could not have foreseen the many fine houses that were to be built in Portsmouth in the coming centuries. Cited by an American Institute of Architects' study for having the greatest concentration of architecturally significant buildings from the 1700s and 1800s between Charleston, South Carolina and Alexandria, Virginia, Portsmouth's Olde Towne and downtown offer a treasure trove of lovely houses, inspiring churches, and quaint commercial buildings. Homes in the Historic Districts of Cradock, Truxtun, Park View, and Port Norfolk also grace the city with the charming architecture of bygone days. Though the following pages provide a record of some historic houses, this book is primarily the story of a port city and its people as they have endured calamities, shared prosperity, and raised loving families for over two centuries. Enjoy the legends, facts, and sights as you discover Portsmouth, Virginia!

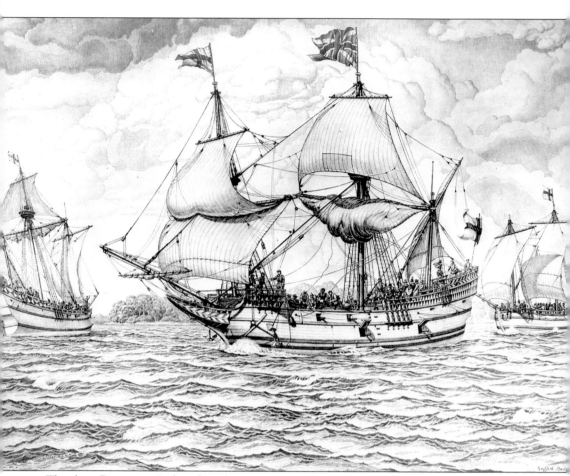

The ships *Discovery, Godspeed,* and *Susan Constant* brought the English colonists who founded Jamestown in 1607. Leading a 12-man expedition that explored the Virginia rivers south of Jamestown in 1608, Capt. John Smith almost certainly saw the land that now constitutes Portsmouth. Shown here is the sketch of the three first English ships as made by Griffith Bailey Coale in 1948 for a painting in the Virginia State Capital at Richmond. (Courtesy Portsmouth Public Library.)

One

COLONIAL AND EARLY NATIONAL PERIODS

Just 16 months after English colonists founded Jamestown in the spring of 1607, a 12-man expedition led by Capt. John Smith explored nearby waters, finding "garden plots" and other signs of Native American presence. They probably saw the land that became Portsmouth as they "sayled six or seven myles" up the Elizabeth River. Colonists moved south from Jamestown as the colony became more established.

Twelve years later, John Wood asked for 400 acres located on the Elizabeth River "because thereon is timber fitting for his turne and water sufficient to launch such ships as shall be there built." It would be 150 years before the founding of the famous Naval Shipyard in Portsmouth, but the idea for it was thus recorded in the spring of 1620, about six months before the Pilgrims left England for Plymouth Rock.

After 16 more years, there was enough settlement to justify regular ferry service between what would become the modern cities of Portsmouth and Norfolk. Adam Thoroughgood is credited with its establishment in 1636.

Capt. William Carver began acquiring the land that would become Portsmouth, but he was hanged for his role in Bacon's Rebellion in 1676. Forty years later, Carver's holdings were included in the property of Col. William Crawford. From 65 acres of this land donated by William Crawford, Portsmouth became a town on February 27, 1752. Crawford laid out the streets in an orderly grid, and he made narrow streets alternate with the wide ones on which more prosperous people would live. Quarter-block lots were laid out in squares, which had names such as "Oxford" and "Red Lion." He designated the four corners at High and Court Streets for public use, establishing space for a court house, a market, a jail, and a church. Colonial Virginia only allowed the Church of England, and portions of Portsmouth's first church, later named Trinity Episcopal Church, have stood on the present site since being completed in 1762, the year of Crawford's death.

Portsmouth more than doubled in size by extending west to Washington Street when Thomas Veale's lands were annexed in 1763. Scotsman Andrew Sprowle started a shipyard about a mile south of the town in 1767. He called it Gosport (short for "God's Port") because of the famous shipyard by that same name near Portsmouth, England.

In 1772 Methodism arrived in Portsmouth, and today's Monumental United Methodist Church is the oldest continuous Methodist congregation in the South. Slaves also attended Monumental though they sat apart, and Emanuel African Methodist Episcopal Church thus can trace its beginnings to the same date of origin.

The shipyard prospered, and Andrew Sprowle became British Naval Agent. When the last English Governor, the Earl of Dunmore, fled from Williamsburg in 1775, Sprowle gave him a warm reception and shelter. For months thereafter, Portsmouth's Gosport shipyard effectively became the seat of British government in Virginia.

After Lord Dunmore declared martial law on November 7, 1775, he promised freedom to slaves and indentured servants who aided him. An "Ethiopian" unit fought alongside his Tory forces during raids from Portsmouth and at the Battle of Great Bridge on December 9, 1775. Defeated there, Dunmore took revenge by opening fire on Norfolk with more than 100 guns before sending parties to set fires there on New Year's Day of 1776. Dunmore later moved to the location of today's Naval Hospital and built fortifications. In May 1776 the governor fled with his forces to Gwyn's Island in what today is Mathews County. Andrew Sprowle died there. From that island, the last royal governor abandoned Virginia during August of 1776.

Meanwhile Gen. Charles Lee had taken charge of Portsmouth and, feeling the town was "a hotbed of Toryism," burned down a number of Portsmouth homes along with wharves, warehouses, and two merchant ships.

Fortunately, the Fourth Virginia Regiment that occupied the town that June did no further damage to Portsmouth. Instead the soldiers constructed Fort Nelson on the point of land that is now the site of the Naval Hospital.

As impressive as Fort Nelson's 14-foot parapets and cannon would become, the fort could not block Commodore Sir James Collier's six warships and 1,800 troops on May 9, 1779. British forces destroyed the Gosport shipyard and 137 ships there, greatly impairing Revolutionary supply lines and ship-building capabilities.

The British returned in November of 1780 with over 2,500 soldiers who conducted raids from Portsmouth, but they left the town by the middle of the month. By the end of December a new British force under the command of Brig. Gen. Benedict Arnold, the famous traitor, occupied and fortified the city before conducting raids against Hampton and other nearby Revolutionary strongholds. Maj. Gen. William Phillips brought more than 2,000 additional troops the following March, and major actions were taken against Williamsburg and Petersburg. Though Lord Cornwallis arrived in July, he quickly left Portsmouth on August 20, 1781 and moved his troops to Yorktown. His subsequent defeat on October 19, 1781 led to the end of British rule and the birth of the United States.

In 1784 Portsmouth annexed Gosport. Adding that land between South Street and the shipyard, Portsmouth grew to three times its original 1752 size.

In 1785 Baptists established Shoulder Hill Baptist Church, now Churchland Baptist Church, far to the west of the old city but in an area that is now part of Portsmouth. Four years later, the Portsmouth and Norfolk Baptist Church, now Court Street Baptist, was organized on September 7th. African Americans at Zion Baptist Church can claim close connection to the same 1789 origin

By 1790, Portsmouth's population numbered 1,039 white, 616 slaves, and 47 free African Americans. One of the former slaves from Revolutionary days was James Lafayette, whose services as a spy won him his freedom and a lifetime pension by an act of the Virginia General Assembly. William Flora, who fought bravely as a free man at the Battle of Deep Creek in 1775, said he'd "be buttered" if he wouldn't fight them again when the tensions that led to the War of 1812 began to mount. That was reported to be the strongest language he ever used.

Moreau de St. Mery's account of a visit to Portsmouth in 1794 records it as having a deeper port, better water, and a healthier climate than Norfolk. He records six ferries being rowed between the two cities, and he admired one rower, a slave named Sam, who had taught himself to read and write. Interestingly, an ad for the return of Sam, then a runaway slave, appeared in the local newspaper only a few years later.

In 1801 the federal government purchased the Gosport Navy Yard from Virginia, making Portsmouth's shipyard the first such federally owned facility in the nation. Portsmouth became the county seat of Norfolk County in 1803, and a court house and jail were built at High and Court Streets that year. Despite these impressive changes, its population only increased by about 380 residents between 1794 and 1810.

In the meantime, the USS frigate Chesapeake, the first major ship built in Portsmouth for the Navy, was launched on December 2, 1799. The boarding of the Chesapeake by the British ship Leopard in 1807 helped lead to the War of 1812. Capt. James Lawrence was commanding the Chesapeake off the coast of Massachusetts on June 1, 1813 when he uttered the famous watchwords of the United States Navy, "Don't give up the ship."

British ships came to occupy Portsmouth by force on June 22, 1813, but they were turned back at the Battle of Craney Island. With the end of the War of 1812, Portsmouth began a long period of growth.

The arrival of the steamboat Washington on May 24, 1815 began an era of greater commerce and easier travel. President James Monroe came to inspect the shipyard and Fort Nelson in 1818.

In 1820 the warship Delaware was launched from Gosport. Also that year, the nation's first lightship, a vessel with a bright beacon that marked treacherous waters, took its station off of nearby Craney Island. The Great Fire of 1821 destroyed many houses north of London Street that year.

The Marquis de Lafayette came in 1824, and the city was decorated in grand fashion as citizens welcomed the French hero of the American Revolution. The triumphal arch, erected at the foot of High Street for him, is recalled today in a brick arch that stands in Lafayette Park on the southeast corner of Crawford and Glasgow Streets.

The first fire-fighting company, the Resolution Fire Company, was organized in 1830. That same year, the new United States Naval Hospital opened after three years of construction.

In 1832, Dr. William Collins, First Auditor of the Treasury under Presidents Polk and Tyler, organized the Portsmouth and Roanoke Railroad. The next year, President Andrew Jackson arrived for the dedication of the nation's first drydock at Portsmouth. By 1840, Portsmouth's character as a growing port city with an important Naval Hospital and Naval Shipyard was established.

Parts of an early home of William Crawford still exist in this handsome house at 200 Swimming Point Walk near the Naval Hospital. Revolutionary War hero Richard Dale's family once lived here. According to the research of the Portsmouth Public Library's Wilson Room Historian Barnabus W. Baker, the home was inherited by Crawford from his grandfather so the modern home contains parts of what is probably the oldest house in Portsmouth and one of the oldest in Hampton Roads. (Courtesy Portsmouth Public Library.)

Crawford built another home when Portsmouth was still a great wooded area, as shown in this modern painting by artist J. Robert Burnell. In this scene, William Crawford drives along what will become High Street from his fine home at what is now the southeast corner of High and Crawford Streets. The simple dirt road helps explain why shipping was the main source of transport in the 1700s, whether for travel or for transport of an important crop such as tobacco, which can be seen being loading onto the ship in the background. (Courtesy J. Robert Burnell.)

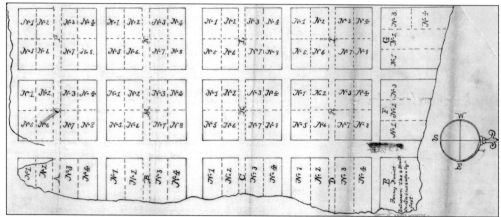

In 1752, Col. William Crawford laid out the streets of Portsmouth on 65 acres of land. This surveyor's map shows three streets ran from north to south—Court Street to the west (top of this map), Crawford Street to the east, and Middle Street in between. From left to right, the street names are South, Crab, County, King, High, Queen, London, Glasgow, and North. The large area at the lower right was dedicated for use by the ferries which had connected Norfolk and Portsmouth since 1636. (Courtesy Portsmouth Naval Shipyard Museum.)

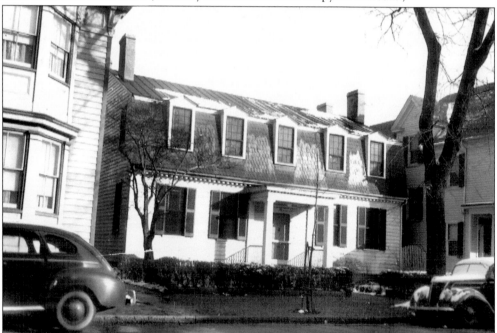

This Colonial "tax dodger" house at 417 Middle Street features a gambrel roof that allowed lower taxes than a usual two-story home would have had to pay under the British tax code of about 1750. Used as a barracks in the War of 1812, notables entertained here included Lafayette, the French friend of the Revolution, in 1824, and President Andrew Jackson in 1833, when he came to the dedication of the nation's first dry dock in Portsmouth. The home was moved from the northeast corner of Crawford and Glasgow Streets to its present site in 1869 when the railroad expanded along the waterfront. The home at the left was built in 1860 and the one at right was constructed in 1909. The photograph is from 1947. (Courtesy Portsmouth Public Library.)

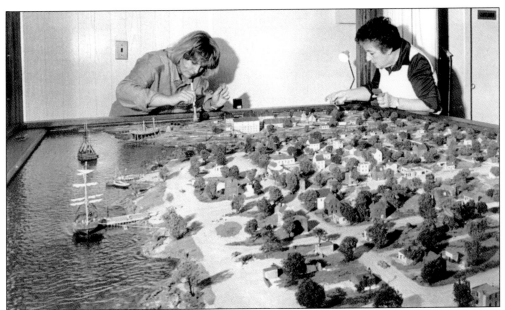

After the land of Thomas Veale was annexed in 1763, Portsmouth extended west to Washington Street and covered about half a square mile. Settlement to the south was spurred in 1767 when Andrew Sprowle founded a shipyard, which he named after Gosport Shipyard near Portsmouth, England. This picture shows a model of late 18th-century Portsmouth being cared for by Shelly Gluce (left) and Alice Hanes, second curator of the Portsmouth Naval Shipyard Museum. (Courtesy *Virginian-Pilot and Ledger-Star*.)

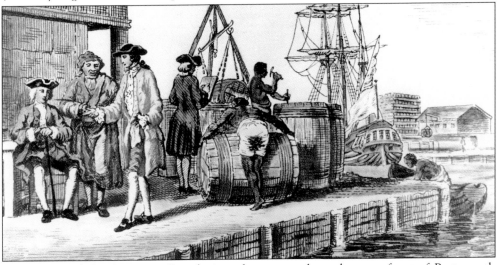

On the eve of the American Revolution, the scenes along the waterfront of Portsmouth were probably very similar to this one from a map of 1775. African Americans, both free and slaves, worked at this seaport as laborers as well as craftsmen, and few areas of life were not touched by their efforts. A French map of the period shows the "Habitations de Negrea" west of what is now northern Effingham Street. Former assistant librarian William A. Brown has speculated that the Lincolnsville neighborhood, which was heavily populated by African Americans until redevelopment in the 1970s, thus may have had a Colonial origin. (Courtesy Portsmouth Public Library.)

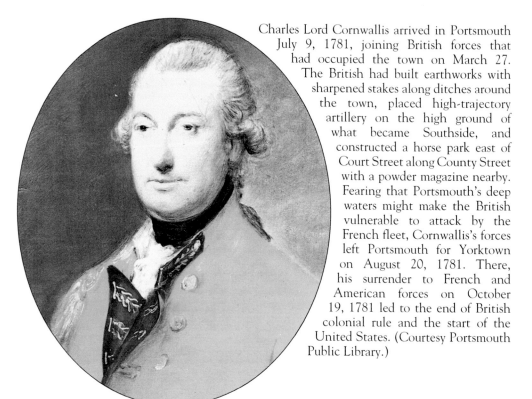

Charles Lord Cornwallis arrived in Portsmouth July 9, 1781, joining British forces that had occupied the town on March 27. The British had built earthworks with sharpened stakes along ditches around the town, placed high-trajectory artillery on the high ground of what became Southside, and constructed a horse park east of Court Street along County Street with a powder magazine nearby. Fearing that Portsmouth's deep waters might make the British vulnerable to attack by the French fleet, Cornwallis's forces left Portsmouth for Yorktown on August 20, 1781. There, his surrender to French and American forces on October 19, 1781 led to the end of British colonial rule and the start of the United States. (Courtesy Portsmouth Public Library.)

Portsmouth-born Commodore Richard Dale was a lieutenant in the Virginia Navy in 1776. He served as first lieutenant under John Paul Jones on the *Bonhomme Richard.* After Captain Jones defiantly said, "I have not yet begun to fight," Lieutenant Dale was the first to leap aboard the British ship *Serapis* during that famous naval battle on September 23, 1777. Promoted to captain in 1783, he became superintendent of the Gosport Navy Yard in 1794 and a commodore in 1801. A portion of a home that he himself may have built on the site of his birthplace still stands in the Waterview section of the city, at what formerly was known as Dale's Point. (Courtesy of Portsmouth Public Library.)

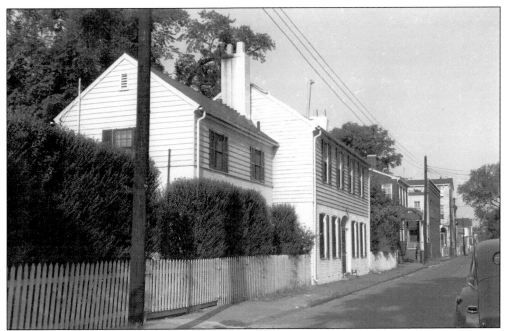

Portions of the old city market from about 1780 still exist in this home at 215 Glasgow Street. When a new city market was built at High and Crawford Streets in 1870, the old building was moved to this site. Markings for the vendors' stalls still exist in the eaves. A wing at the eastern side (shown here) and an enclosed area to the south were added in the 1950s. Immediately to the west was the site of Portsmouth Academy, which was founded in 1825 as a private school, became Portsmouth's first public school in 1847, and as Glasgow Street Academy graduated the city's first high school class in 1885. This J. Walker photograph was taken in August of 1965. (Courtesy *Virginian-Pilot* and *Ledger-Star*.)

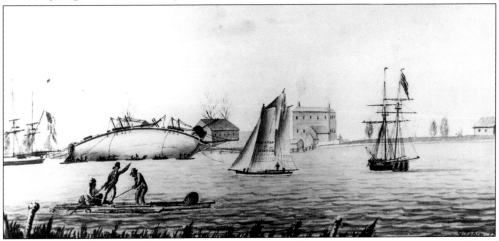

Britain was at war with France when the English ship *Thetis*, a 36-gun frigate was pulled over on its side, or "careened," so that work could be done on the ship's hull. Scottish entrepreneur Andrew Sprowle founded the Gosport Shipyard as a careening and repair facility after buying the land in 1767, just 15 years after Portsmouth was founded. This watercolor by G. Tobin captures the few simple buildings that made up the Gosport Shipyard (in the background) in 1795. (Courtesy Portsmouth Naval Shipyard Museum.)

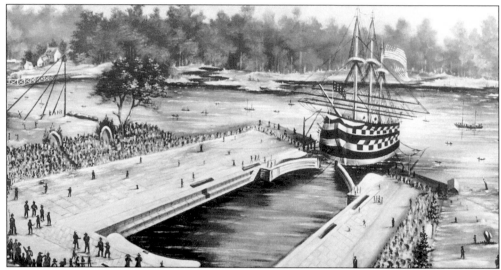

The first dry-docking in America is shown as the USS *Delaware* entered Dry Dock Number One at the Gosport Navy Yard on the morning of June 17, 1833. People came from miles around and the event drew President Andrew Jackson and his cabinet from Washington to see it. Dry docks ended the need for ships to be careened in order to be repaired, and the excitement and importance of the first dry-docking was so great that a series of four engravings were drawn by J.G. Bruff to capture the event (Courtesy Portsmouth Public Library.)

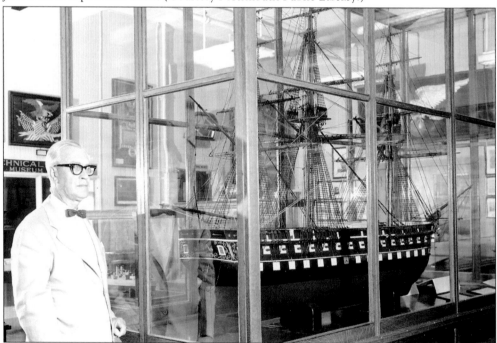

The keel of the 2,633-ton, 74-gun USS *Delaware* was laid in August of 1817 at Portsmouth's Gosport Navy Yard. The first major ship to be built at Gosport, it was burned and sunk by fleeing Union forces at Gosport on April 20, 1861. Here, a model is inspected by Marshall Wingfield Butt Sr., the first president of the Portsmouth Historical Association and the founder of the Naval Shipyard Museum in 1949. (Courtesy Portsmouth Public Library.)

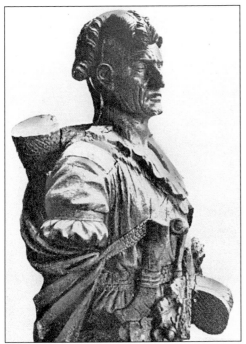

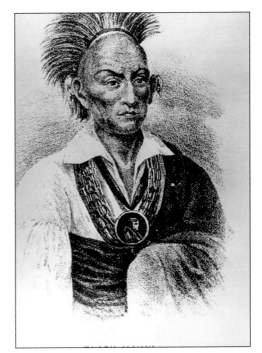

(*above, left*) A likeness of Tamanend, chief of the Delawares, was carved by William Luke of Portsmouth to grace the prow of the ship that bears the name of his tribe. A replica of this figurehead of the USS *Delaware* still graces the United States Naval Academy at Annapolis, Maryland. (*above, right*) Native-American chief Black Hawk was imprisoned at nearby Fortress Monroe after his defeat near what is now Chicago. To impress him with American might and perhaps discourage a future war, Black Hawk was brought back to Gosport, then as now a shipyard full of military might, but he was remarkably unimpressed with the sights until he saw the *Delaware*. Upon seeing the giant warship, it is said his face lit up as he remarked, "Took big man to build that big canoe." (Courtesy Portsmouth Public Library.)

Black Hawk was entertained in 1816 at the home of Samuel Watts, now located at 500–502 North Street but originally north of that spot on Ben Lammond, the Watts family property west of the tidal flats. The house was built around 1790 by Dempsey Watts and moved to its present site about 1909. The famous orator Henry Clay was entertained here in 1824. (Courtesy Portsmouth Public Library.)

17

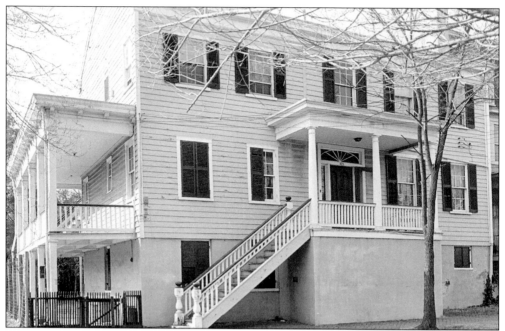

Sea captain William Pritchard's home at 525 North Street was built around 1789, almost 200 years before this 1978 photograph was taken. This style of home was extremely popular in Portsmouth in the 18th and 19th centuries, for guests ascended to the temperate second floor to enter formal rooms that were high above the noise and dirt of urban streets. Sometimes called a Bristol-built house, a home of this style is also termed an English Basement or basement-style house. (Courtesy *Virginian-Pilot and Ledger-Star*.)

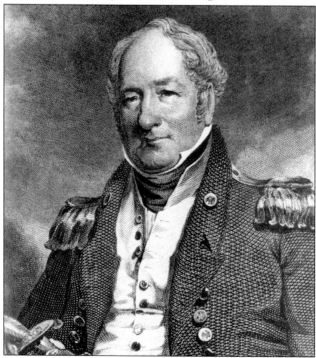

Commodore James Barron was born in Portsmouth in 1769, served in the Virginia Navy during the Revolution, and rose steadily in the ranks of the United States Navy, becoming a lieutenant in 1798, a captain in 1799, and commodore in 1807. He was commandant of the Navy Yard in 1825–1831, and he lived until 1851. He was best known as the man who shot and killed Stephen Decatur in a duel caused by their dispute over the 1807 Chesapeake-Leopard affair that led to the War of 1812. The Commodore Theater was named after him, for it is adjacent to his tomb in the churchyard of Trinity Episcopal Church. (Courtesy Portsmouth Public Library.)

Converted to a duplex by the time of this photo, this was the home of Josiah Parker, who commanded Virginia militia that were to hold Portsmouth if Cornwallis attempted to return in 1781. A former aide to General Washington and a member of the Society of the Cincinnati, Parker became the first congressman from this district. Located at the northwest corner of Glasgow and Crawford Streets, Parker's house was near the home of a prominent Tory, the Rev. John Agnew, which was at the southwest corner of Crawford and North Streets. The Parker house was torn down by its owner in the 1960s. (Courtesy Portsmouth Public Library.)

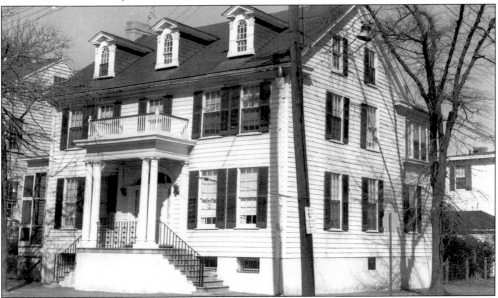

The Leigh-Whitehead House at 300 North Street is a fine example of Federal architecture. Its classical porch is complemented by a fan window over the front door. The antebellum home to its right at 334 Middle Street was built by William Henry Harrison Hodges, a banker imprisoned for two years at Fortress Monroe for refusing to surrender the bank's papers during the Union occupation of Portsmouth. Elected mayor in both 1857 and 1858, he also served the city as president of the Library Association. He built his home next to the corner house that had been occupied by his father, Gen. John Hodges, who fought in the Revolutionary War. (Courtesy Portsmouth Public Library.)

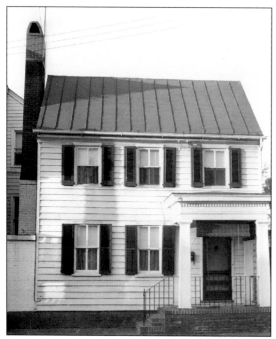

The Collier House at 410 London Street probably dates from 1800 to 1830. Its size is more typical of the homes of that period, for large homes were expensive to build and difficult to heat. The massive chimney at its west side must have kept this small house cozy. (Courtesy *Virginian-Pilot and Ledger-Star*.)

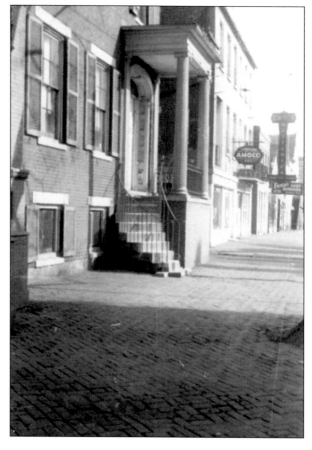

Built at the northeast corner of Crawford and Queen Streets by Dr. Robert Bruce Butt in 1820, this brick home's unusual winding staircase greeted guests. Already threatened by the growth of the commercial High Street corridor as shown when this picture was taken in the 1940s, it was torn down in 1959 to make room for the current Federal Building. (Courtesy Portsmouth Public Library.)

Inside the Butt home, the winding steps outside were mirrored by this interior spiral staircase. The staircase was unsupported, so this was quite an elegant feat of engineering for 1820. Interiors of a number of surviving Olde Towne homes are available in a color publication available from the Olde Towne Civic League, P.O. Box 35, Portsmouth, Virginia 23705. (Courtesy Portsmouth Public Library.)

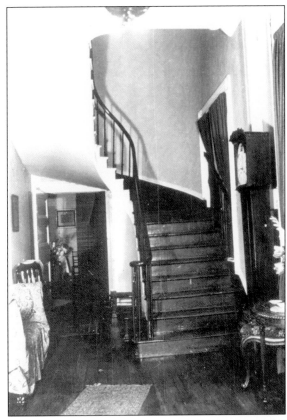

Tradition says that Captain Baird built this home around 1820. Subsequent changes have obscured much of its lovely Greek-Revival form, especially massive additions to the northern side shown at right. The building still survives in Olde Towne South at the northwest corner of Dinwiddie and South Streets. (Courtesy Portsmouth Public Library.)

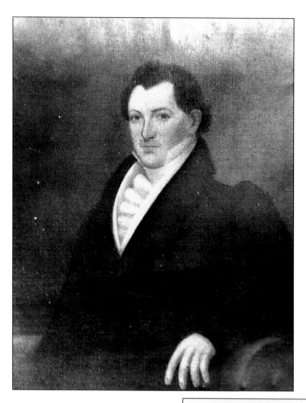

William Collins organized the Portsmouth and Roanoke Railroad. When the bill authorizing the final financing narrowly passed the Virginia legislature on January 19, 1834, church bells rang and great guns fired in both Norfolk and Portsmouth while a series of field pieces placed at suitable distances fired one after another to take the news to Suffolk that a railroad would be coming to bring prosperity to the region. Shown here c. 1840, Collins was to die in the Yellow Fever epidemic of 1855, but his efforts to keep the railroad running throughout the crisis caused him to be remembered as a hero. (Courtesy Portsmouth Public Library.)

The last rail to Suffolk was laid on July 27, 1834, and regular service followed the next day with horse-drawn carriages. On September 24, 1834, locomotive service began, but it was not until December 31, 1836 that the 74-mile line to Weldon, North Carolina was completed as originally envisioned. Fifty years later, the railroad advertised "connection to all points north and south." Later known as the Seaboard Air Line Railroad, it became a major Southern carrier of goods and people and spurred Portsmouth's economy for years to come. (Courtesy Portsmouth Public Library.)

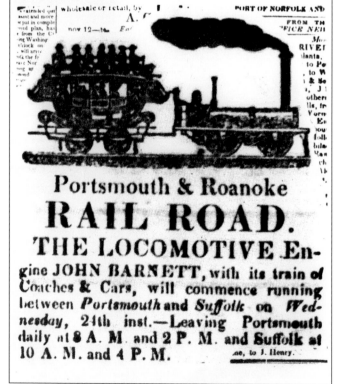

Two

YELLOW FEVER, WAR, AND RECONSTRUCTION

Because of Portsmouth's growing importance, United States presidents visited the town. In 1838 President Martin Van Buren stayed at Portsmouth's first five-story hotel, built in 1835 as The Crawford House. The 1840s saw Portsmouth welcome Presidents John Tyler in 1843 and James K. Polk in 1846. The decade also witnessed the opening of the first public school, the Portsmouth Academy, in 1847 on Glasgow Street.

Some of Portsmouth's men went to fight in The Mexican War in 1846. President Millard Fillmore, as well as a hero of that war, General Wingfield Scott, visited the town in 1851. That year the Page and Allen Shipyard was established in Portsmouth's Gosport neighborhood, and the firm later built the only clipper ship ever built in the South, Neptune's Car.

Portsmouth had been governed by a board of trustees, but in its centennial year of 1852, the town began to be ruled by a mayor and council. It also divided the town into two wards, Jackson and Jefferson. A gala celebration was held in honor of the town's first 100 years.

The Portsmouth Gas Company was organized on February 11, 1854 and brought modern lighting to the town. Two major new hotels, The Macon House and The Ocean House, opened in 1855. The future looked bright for the growing town.

Being a port had meant dangerous exposure to disease, and the city had already endured epidemics of cholera in 1821 and 1849, but nothing compared to the jolt Portsmouth had on July 8, 1855. "A perfect horror" fell over the town as news spread of a death from Yellow Fever. Though it was a Sunday, the Town Council met in extraordinary session and quarantined the ship Benjamin Franklin, which brought the sickness. By July 27, however, the disease was spreading throughout Gosport. The Council authorized a hospital, and it was built within two days. As Drs. George W.O. Maupin and John Trugien prepared the hospital, Father Francis Devlin, priest at St. Paul's Roman Catholic Church, and Rev. James Chisholm, rector of St. John's Episcopal Church, went to Gosport to assist the ill and stem the panic. Fear spread as Yellow Fever appeared in Norfolk, and both Suffolk and Smithfield refused any traffic from either city. Those who attempted to flee by boat to Old Point found army troops with fixed bayonets making sure that they turned back. As the epidemic increased, the Naval Hospital opened its doors to the stricken civilian population and the staff was soon stretched to the limit in caring for the ill. Orphaned children were so plentiful that they were a major problem, and the Naval Hospital cared for them until a makeshift orphanage was created in the Academy building on Glasgow Street. When the epidemic ended three months later, 10 percent of the people of Portsmouth and of Norfolk had died, including Father Devlin and Reverend Chisholm.

Two years later, a different sort of trial was visited upon the town. The Great Storm of 1857 brought six-foot snow drifts and temperatures that reached nine degrees below zero. The harbor froze and not only residents but horses could cross to Norfolk on the thick ice.

The next year, 1858, Portsmouth ended its position as a town within Norfolk County and became an independent city. The following year, President James Buchanan visited the new city.

Although Portsmouth had overwhelmingly voted against secession, the Virginia legislature voted unanimously to leave the Union in April of 1861. The story of how Portsmouth's naval shipyard was burned by retreating federal

forces, how the world's first ironclad ship, CSS Virginia, was built in 1862, and how that changed naval history is shown in following pages.

Union troops had occupied Portsmouth since May of 1862 without major incident, but Special Orders #44 by Gen. A.E. Wild on February 25, 1864 brought national attention to the city. General Wild jailed the Reverend Wingfield, minister at Trinity Episcopal Church, and sentenced him to three months of cleaning the streets of Norfolk and Portsmouth for raising his head during the Prayer for the President of the United States. Religious leaders and others from across the United States wrote in outrage that freedom of religion was being violated, and the minister was freed.

During the years of occupation, many Portsmouth men were away fighting for the Confederacy. Although there were only 900 male voters when the war began, 1,400 men took up arms for the South and sixteen percent of them died before the war ended in 1865.

The wording of a memorial window to Portsmouth's Confederate dead at Trinity Episcopal Church in 1868 resulted in the ultimatum by the Secretary of the Navy to remove wording he found offensive or have the city's Navy Yard closed, throwing a thousand men out of work. A new window was installed.

In 1870, Virginia became Military District Number One as part of the process called Reconstruction. Despite the realities of military rule, life was getting back to normal. Former Confederate general Robert E. Lee traveled through Portsmouth on April 30th.

The status of African Americans improved during the post-war years. In 1865, the first deed registered by African Americans in Portsmouth was for Zion Baptist Church on Green Street property donated by Richard Cox, a member of Court Street Baptist Church. Chestnut Street School, the first public school for African-American children, opened in 1878. Israel Charles Norcom became its best-known principal, and two high schools have since borne his name.

Better times were evident as telephone service began in 1884 and as Portsmouth's first public high school class graduated in 1885. Horse-drawn streetcars started running on the Portsmouth Street Railway in 1887, and electric streetcars began service in 1897. All of Portsmouth's citizens began to benefit as economic growth began making Portsmouth a prosperous modern city.

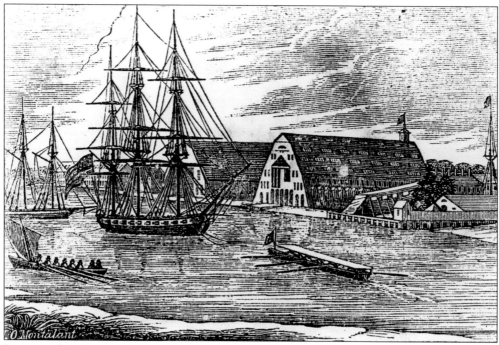

Portsmouth's Gosport shipyard was thriving at the time of this 1843 engraving by J.O. Montalant. On June 15, 1801, the federal government had bought the Gosport Navy Yard from Virginia. The price for its 16 acres was $12,000. (Courtesy Portsmouth Public Library.)

The Odd Fellows Hall, a fraternal organization that held meetings on the second floor, was constructed as a two-story Greek-Revival building in 1839. In the late 1800s, the roof and second story were raised and a third story was built in between as the structure was converted to an apartment building. (Courtesy Portsmouth Public Library.)

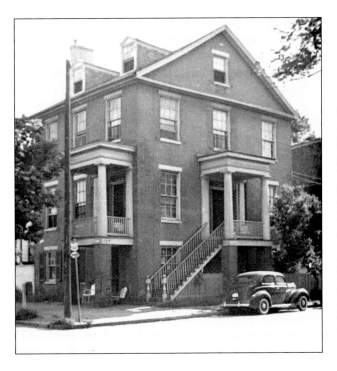

The William Murdaugh House (pronounced "Murdah") was built c. 1841. It is better known as The Pass House because it was the place where the adjutant general issued passes to those who wished to leave Portsmouth during the Union occupation of the city from 1862 to 1865. A happier story recalls that a young Lieutenant Lejeune, for whom the Marine Corps' Camp Lejeune is named, proposed to his wife in the front parlor of this attractive basement-style home. (Courtesy Portsmouth Public Library.)

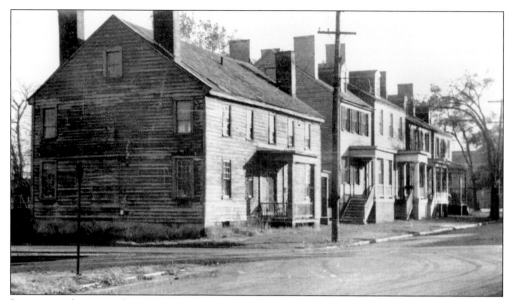

Just across the street from The Pass House, three similar basement-style homes were also built in 1840 and, according to local lore, each story was allowed to settle for a year before another story was added. Tradition also says the wooden house to their left was built by the owner of the lumber yard who wished to show that a house of wood could be as fine as any brick home. Edmund Pryor's home (in the foreground) was said to date back to the 1700s. It was demolished c. 1960, and the Lafayette park was established in the late 1970s on that southeast corner of Crawford and Glasgow Streets. (Courtesy Portsmouth Public Library.)

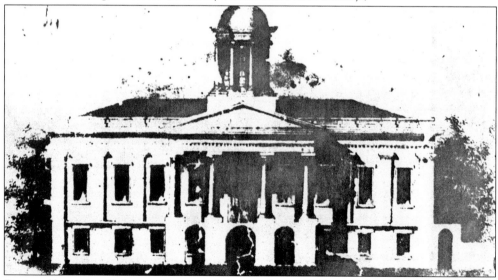

Designed by nationally known Portsmouth-born architect William B. Singleton, the 1846 court house is shown here as it appeared in the Rolin and Keily map of 1851. Its handsome cupola was restored under the guidance of prominent architect John Paul C. Hanbury after the Portsmouth Museum and Fine Arts Commission obtained the building. The building was placed on the National Register of Historic Places in 1970 and it opened in June of 1984 with an art gallery on the second floor and the Children's Museum of Virginia. The Garden Club of Virginia donated the landscaping. (Courtesy Portsmouth Public Library.)

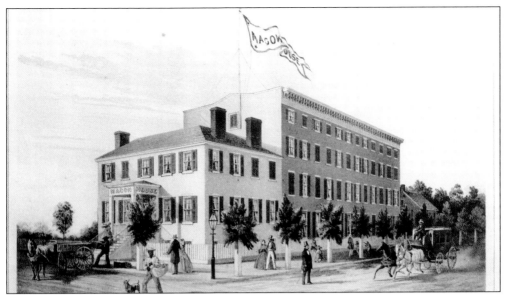

The Macon House Hotel was opened in 1855, just about two blocks west of the ferry landing at the foot of North Street. The entrance was an independent home built about 1830 by William Wilson at the southwest corner of Middle and North Streets. According to local lore, in later years a pony cart carried bathers about a block north to bathe in the clean waters of the Elizabeth River and a formal garden with a view of the waterfront was established in the block northeast of the hotel. Today, the entrance area is again a private home and its lodging section has been transformed into three apartment buildings. (Courtesy Portsmouth Public Library.)

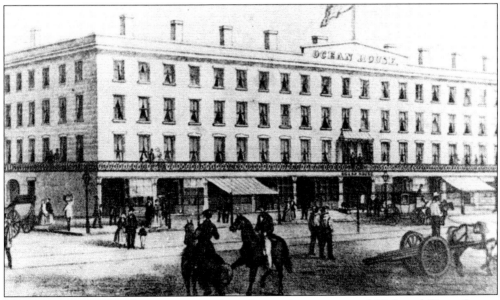

The Ocean House Hotel was constructed on the northeast corner of High and Court Streets in 1853–1855 by Col. Winchester Watts and Col. Arthur Emmerson. In 1861, the Sisters of Mercy, formed by Portsmouth women as the first formal nursing group in the Confederacy, established its hospital here. President Franklin Pierce gave a rousing speech from its wrought-iron gallery. Later named the Hotel Monroe, it was destroyed by fire on August 9, 1957. (Courtesy Portsmouth Public Library.)

REPORT

OF THE

Portsmouth Relief Association

TO THE

CONTRIBUTORS OF THE FUND

FOR THE

RELIEF OF PORTSMOUTH, VIRGINIA,

DURING THE

Prevalence of the Yellow Fever in that Town in 1855;

THE

EXHIBIT OF THE TREASURER

OF THE

RECEIPTS AND DISBURSEMENTS OF THE FUND,

AND

STATEMENTS OF OTHER MEMBERS OF THE ASSOCIATION;

TOGETHER WITH A

SKETCH OF THE FEVER, ETC., ETC.

RICHMOND:
H. K. ELLYSON'S STEAM POWER PRESSES, 147 MAIN STREET.
1856.

The ship *Benjamin Franklin* carried Yellow Fever from the island of St. Thomas when it docked in Portsmouth on June 21, 1855. The first case of Yellow Fever was diagnosed on July 8 and within three months roughly one in ten of Portsmouth's residents died of the disease. Nearby Norfolk suffered the same 10 percent casualty rate. (Courtesy of a private collection.)

Funds to construct a new orphanage were collected to house the children whose parents had died in the deadly Yellow Fever epidemic. Over $85,000 was raised and administered by the Relief Committee, composed of D.D. Fiske, James G. Holladay, George W. Peete, Joseph N. Schoolfield, Winchester Watts, Samuel T. Hartt, and Holt Wilson, the treasurer. (Courtesy of a private collection.)

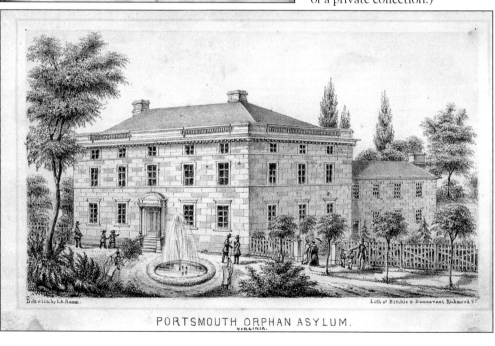

PORTSMOUTH ORPHAN ASYLUM.
VIRGINIA.

Cedar Grove Cemetery was started just west of Portsmouth following the Cholera Epidemic of 1832, but in 1855 it was filling with Yellow Fever victims. A portion of Portlock's Cemetery, now Oak Grove Cemetery, was bought for Catholic victims of the epidemic. Today, genealogists and tourists visit Oak Grove and Cedar Grove's for research or to admire the funerary statuary, which merited Cedar Grove a place on the National Registry of Historic Places. In this photograph, the 1960 Naval Hospital can be seen in the right background of Cedar Grove Cemetery. (Courtesy *Virginia-Pilot and Ledger-Star*.)

Emmanuel African Methodist Episcopal Church dates back to 1772, but the current structure was built in 1857. According to local legend, the church was a stop on the Underground Railroad that smuggled slaves to freedom in the North. This drawing is from Pollock's 1886 *Sketch Book of Portsmouth*. (Courtesy Portsmouth Public Library.)

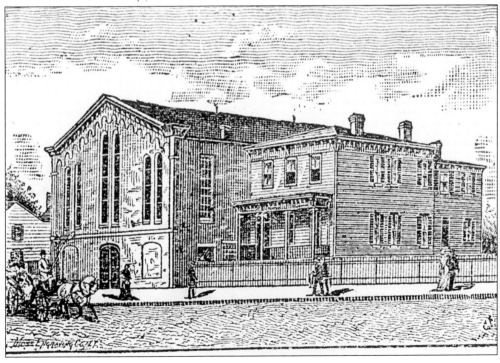

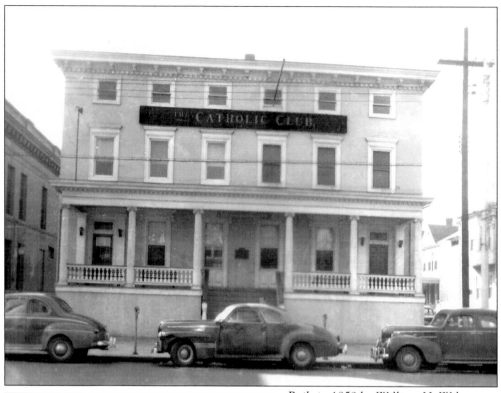

Built in 1859 by William H. Wilson for his two daughters, Mrs. Godwin and Mrs. Hodges, this Greek-Revival house stands at the southwest corner of Court and Queen Streets just north of the 1846 Court House. It features a wide porch, fluted Ionic columns, and dual entrances. At the time of this picture, it was the home of the Catholic Club, a social group that promoted universal brotherhood. Later made into apartments, it now features an art gallery. (Courtesy Portsmouth Public Library.)

William Peters moved his shipyard from the northeastern end of Court Street in order to build his home on that site in 1860. Tradition says the home was designed by Pierre L'Enfant, the renowned architect who designed the street pattern for Washington D.C. (Courtesy Portsmouth Public Library.)

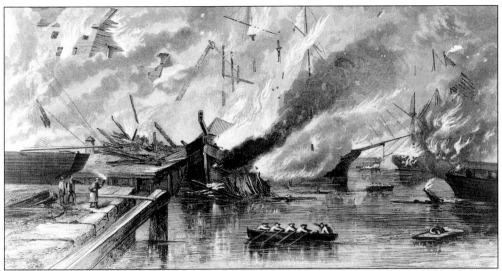

This scene from Victor's *History of the Rebellion* captures the drama of swirling flames that destroyed much of the Naval Shipyard on April 20, 1861. An almost endless supply of Confederate troops had been seen arriving by rail, but the Union commandant did not know that these were the same troops being marched back towards Suffolk and then brought back again. With communications cut off and capture seeming likely, the Union forces set fire to their own supplies and to ships not being used for the evacuation that followed. (Courtesy Portsmouth Public Library.)

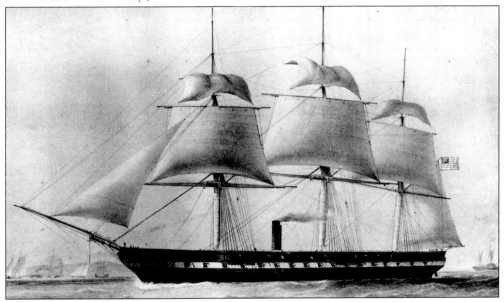

Among the ships burned on April 20, 1861 by the fleeing Union forces was the steam frigate USS *Merrimac*. The *Merrimac*'s guns were among the 1,085 pieces of ordnance that were salvaged from the shipyard for the Confederacy, and the *Merrimac*'s remains were substantially intact since the ship only had burned down to the water line. According to the Portsmouth Public Library's Wilson Room Historian Barnabus W. Baker, his ancestor's wrecking company was paid $5,000 in gold to salvage the remnants of the *Merrimac* for conversion to a Confederate vessel. (Courtesy Portsmouth Public Library.)

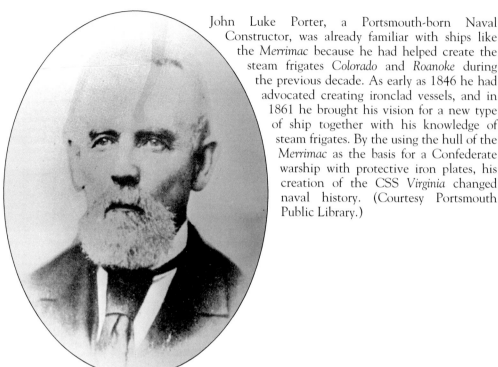

John Luke Porter, a Portsmouth-born Naval Constructor, was already familiar with ships like the *Merrimac* because he had helped create the steam frigates *Colorado* and *Roanoke* during the previous decade. As early as 1846 he had advocated creating ironclad vessels, and in 1861 he brought his vision for a new type of ship together with his knowledge of steam frigates. By the using the hull of the *Merrimac* as the basis for a Confederate warship with protective iron plates, his creation of the CSS *Virginia* changed naval history. (Courtesy Portsmouth Public Library.)

This display from the Portsmouth Naval Shipyard Museum shows the evolution of the world's first ironclad vessel. In the middle is a replica of the hull of the USS *Merrimac*, while below is a model which shows the radically different style of ship which Porter created from the *Merrimac's* remains. In addition to its cannon, the warship featured a ram at the front of the ship (shown projecting to the far left of the model) which provided an additional capability. As shown in the painting, the vessel rode low in water and was thus less vulnerable to damage from enemy guns. The ship was built at Portsmouth's shipyard and named the CSS *Virginia*. (Courtesy Portsmouth Public Library.)

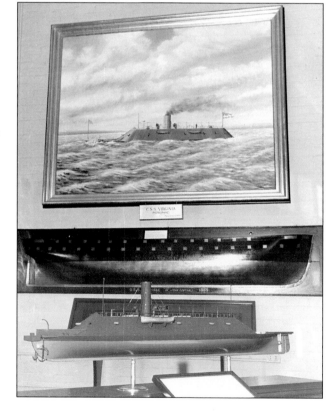

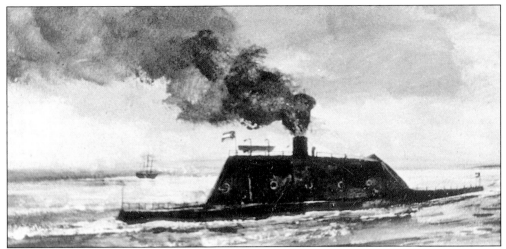

On the morning of March 8, 1862, the CSS *Virginia*'s crew prayed at Trinity Episcopal Church before steaming out to challenge the Union ships that blockaded Hampton Roads. Commanded by Capt. Franklin Buchanan, the CSS *Virginia* sank the *Cumberland* by ramming it, destroyed the *Congress*, drove off the *Roanoke* and *St. Lawrence*, and left the *Minnesota* grounded and helpless. The ability of one armored ship to cause so much damage marked the end of wooden ships of war and the beginning of the modern age of naval warfare. (Courtesy Portsmouth Public Library.)

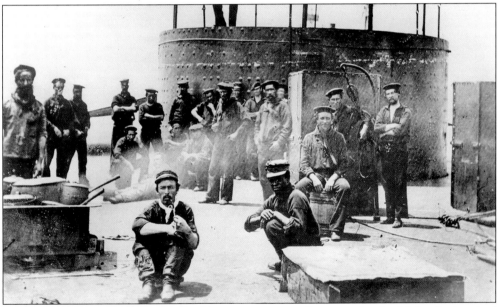

Alerted to the construction that had been going on in Portsmouth, the Union had rushed development of its own ironclad vessel. This had a mobile turret, which turned its two guns to fire in any direction, and it rode very low in the water so it could escape damage from enemy shells. The USS *Monitor*, commanded by Capt. John L. Worden, arrived in Hampton Roads from New York on the night of March 8. With the loss of three ships and the ineffectiveness of the remaining wooden-hulled fleet shown by the battle that day, the *Monitor* prepared to meet the *Virginia*. Here, the crew of the *Monitor* is shown on its deck. (Courtesy Portsmouth Public Library.)

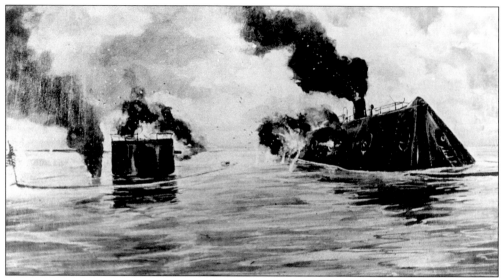

When the *Virginia* sailed out on the morning of March 9, it set fire to the *Minnesota* and sank the tug *Dragon* before being challenged by the *Monitor*. The Battle of the Ironclads followed for four hours at such close quarters that their iron sides struck together sometimes. The engagement ended when the *Monitor* withdrew after its captain was wounded. Two later challenges to the *Monitor* on April 11 and May 8 were not met by the Union vessel. (Courtesy Portsmouth Public Library.)

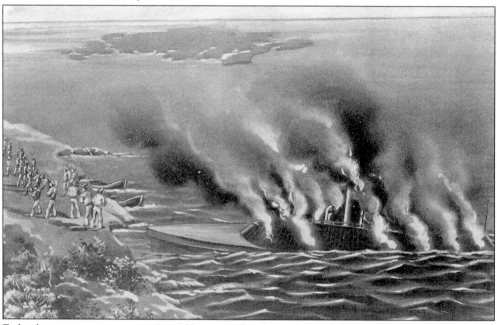

Federal troops were pressing into Hampton Roads, and Confederate forces were ordered to withdraw from Norfolk and Portsmouth. By May 10, the two cities were abandoned and the navy yard was burned again—this time by fleeing Southern forces. Union troops under Maj. Gen. John E. Wool occupied Portsmouth and its shipyard the next day. The CSS *Virginia*, which had run aground due its extreme weight and low draft, was blown up by its own crew near Craney Island just west of Portsmouth on May 11, 1862. (Courtesy Portsmouth Public Library.)

Just as residents of Portsmouth had been split about independence during the Revolution, the populace was divided during this war. In this June 21, 1862 scene from *Frank Leslie's Illustrated Paper*, the raising of the flag of the United States was greeted with cheers by those who favored the Union instead of the Confederacy. (Courtesy Portsmouth Public Library.)

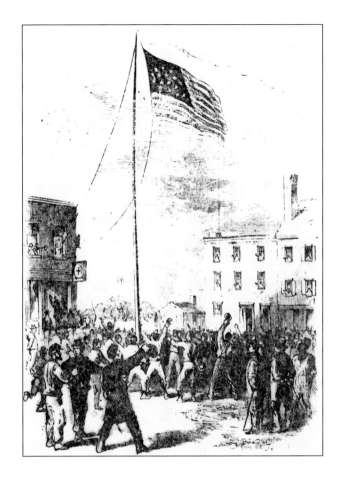

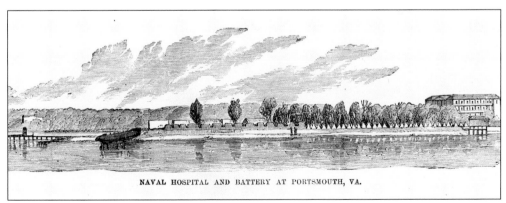

NAVAL HOSPITAL AND BATTERY AT PORTSMOUTH, VA.

During the Union occupation of Portsmouth, a fortification was restored to the tip of Hospital Point (sometimes previously called Musket Point, Mosquito Point, or Windmill Point) and the area between that and the 1830 hospital was covered with tents. Almost every large building in Portsmouth was taken as shelter for wounded Union troops during the period. This scene is from the book *The Soldier in Our Civil War*. (Courtesy Portsmouth Naval Hospital.)

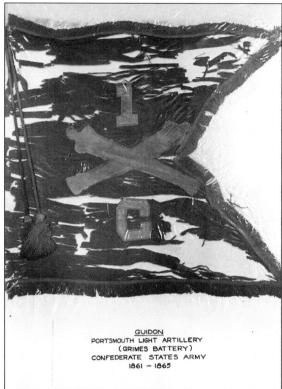

GUIDON
PORTSMOUTH LIGHT ARTILLERY
(GRIMES BATTERY)
CONFEDERATE STATES ARMY
1861 — 1865

Men from Portsmouth continued to fight for the Confederacy for its remaining years. Here, the remains of the flag carried by a Portsmouth artillery unity are shown. The unit was named Grimes Battery after Capt. Cary F. Grimes, and its battle-worn guidon is today among the treasures on display at the Portsmouth Naval Shipyard Museum. (Courtesy Portsmouth Public Library.)

The ruins of the Naval Shipyard are shown in this 1865 photograph. Amazingly, Portsmouth itself was spared such destruction. Though local tradition tells of indignities such as having the Confederate flag placed on the ramp to the ferry so locals would have to tread on it, Reconstruction was a relatively peaceful period as the seaport again became integrated into the economic life of the United States. (Courtesy Portsmouth Public Library.)

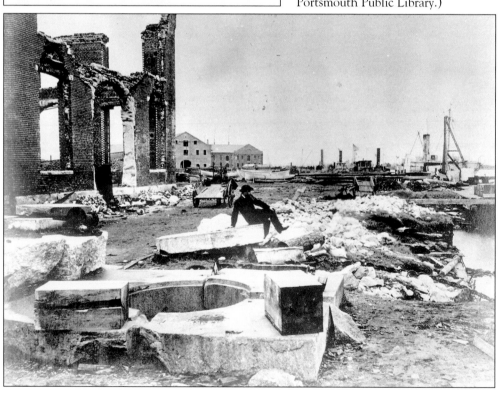

Portsmouth began coming back to life during Reconstruction, as can be seen by the charming ornamentation on this large house at 355 Middle Street built in 1867. Its double porches made living here particularly pleasant in the days before air conditioning. To the left can be seen the Georgian architecture of the 1836 home built by Capt. John Thompson. Its dentil cornices and classic lines make it an imposing structure at the southeast corner of Middle and North streets. (Courtesy Portsmouth Public Library.)

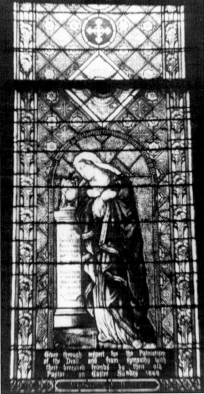

At Trinity Episcopal Church, this beautiful stained glass window was donated by Rev. John Henry Wingfield in 1868. Showing Virginia weeping for her lost sons, it mourned those "who died during the years 1861 and 1865 in defence [sic] of their native State, Virginia, against the invasion by U.S. forces." After the Secretary of the Navy threatened to close the shipyard and thus put a thousand residents out of work, new wording lacking the term "invasion" replaced the original dedication. Both dedications are displayed beneath this lovely window today. (Courtesy Portsmouth Public Library.)

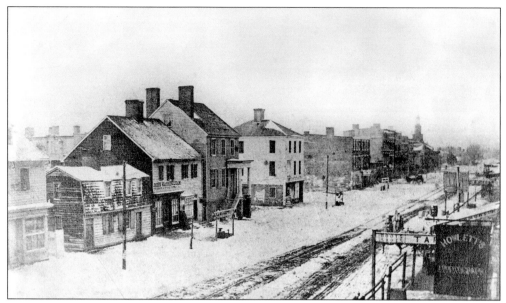

High Street looking west from Crawford Street looked bleak on this winter day in 1871. The sign for Holett's Photography at the lower right probably indicates that someone there took this earliest known photograph of Portsmouth. Streets were still of dirt, and there were few commercial buildings. (Courtesy Portsmouth Public Library.)

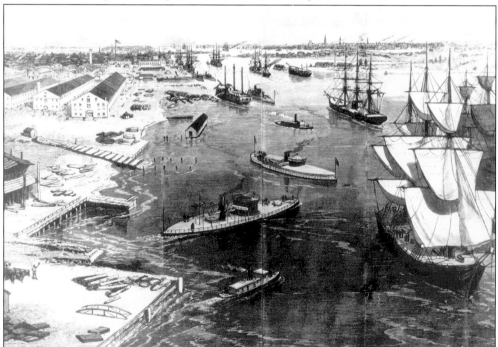

By the nation's bicentennial in 1876, Portsmouth was enjoying renewed prosperity. The Naval Shipyard had been rebuilt and was full of ships. Sail was still a major means of ship propulsion but notice that the *Monitor* class of warships had now become the standard for the United States Navy. (Courtesy Portsmouth Public Library.)

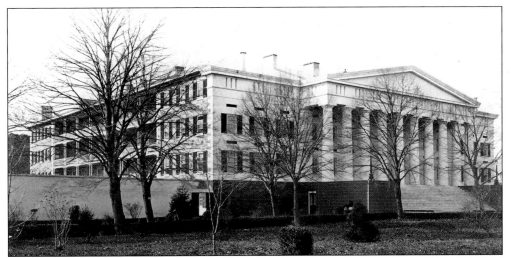

In 1876, the Naval Hospital looked much as it had when completed in 1830. Designed by Philadelphia architect John Haviland, the building was constructed using new bricks as well as many from buildings at Fort Nelson, a fortification built on this point of land during the Revolutionary War. The hospital was a haven for 587 Yellow Fever patients between July 25 and November 10, 1855, and in 1856 Portsmouth had bestowed six gold medals on naval physicians who had helped its citizens at this federal facility. (Courtesy Portsmouth Naval Hospital.)

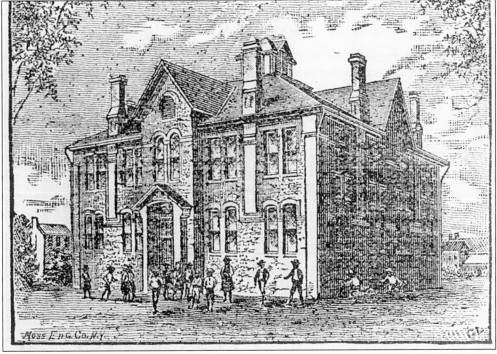

Portsmouth's African-American children were educated at Chestnut Street School, which was built in 1878. Located at 907–917 Chestnut Street, it is shown here in a picture from Edward Pollock's *Sketch Book of Portsmouth* in 1886. I.C. Norcom came here as an assistant teacher in 1883. (Courtesy Portsmouth Public Library.)

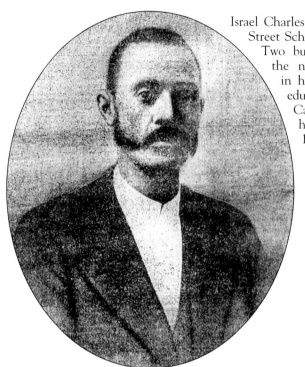

Israel Charles Norcom was principal of Chestnut Street School and later of High Street School. Two buildings in Portsmouth have borne the name "I.C. Norcom High School" in honor of his accomplishments as an educator. Born in Edenton, North Carolina on September 21, 1856, he served as a principal from 1885 until his death on March 18, 1916. (Courtesy *Virginian-Pilot and Ledger-Star*.)

The Bank of Portsmouth listed some of Portsmouth's most notable citizens of the day on its board, and it had obviously thrived since the end of the war in 1865. This advertisement is taken from Edward Pollock's 1886 *Sketch Book of Portsmouth*. (Courtesy Portsmouth Public Library.)

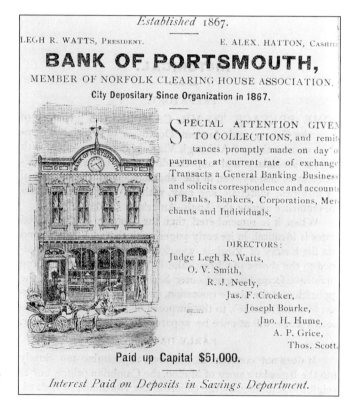

The courthouse had lost its cupola by the time of this view from Pollock's 1886 *Sketch Book of Portsmouth.* This northwest view of the corner of High and Court Streets shows the spire of Monumental Methodist Church on Dinwiddie Street in the left background. (Courtesy Portsmouth Public Library.)

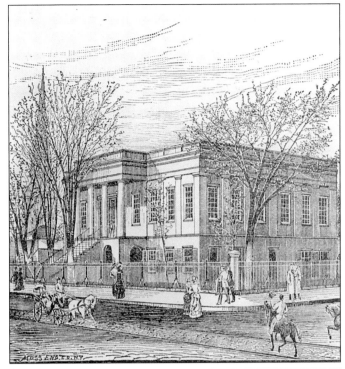

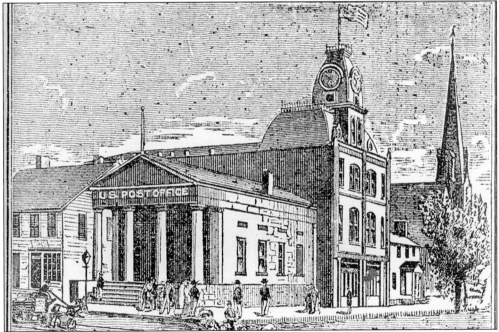

Diagonally across from the courthouse at the southeast corner of High and Court Streets stood the post office, which was built about 1845 for the Virginia Bank. Beside it, the fire department was housed downstairs and municipal offices were upstairs. To its right is First Presbyterian Church. The drawing is from Pollock's 1886 *Sketch Book of Portsmouth.* (Courtesy Portsmouth Public Library.)

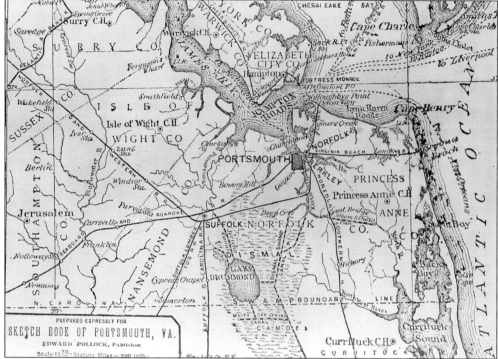

Portsmouth's strategic position is seen in this map from Pollock's 1886 *Sketch Book of Portsmouth*. Rail lines from the south and west connect to Portsmouth, and its deepwater port connects it through the Chesapeake Bay to the world's ports. (Courtesy Portsmouth Public Library.)

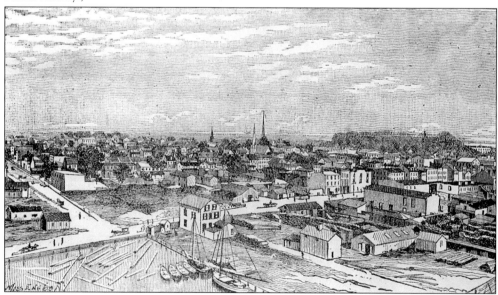

On the eve of The Gay Nineties, Portsmouth seemed to have recovered the economic position it had held 40 years before. This aerial view from Pollock's 1886 *Sketch Book* looks northwest from G. Armstrong & Son's Saw Mill at what today is the foot of Columbia Street but was originally Crab Street. (Courtesy Portsmouth Public Library.)

Three

TURN OF THE CENTURY

Portsmouth entered a new era of growth during the 1890s, fueled in part by activity at the naval shipyard. The USS Texas, the nation's first battleship and the first steel ship built at the shipyard, was launched on June 28, 1892. The cruiser Raleigh had been completed that March, and both would see service in the Spanish-American War near the end of the decade.

In 1894, Portsmouth annexed Park View, an area west of the Naval Hospital's landscaped park. Located on the site of the former Hatton family farm, Park View provided electric lights in its new homes and a handy streetcar connection to downtown. It became Portsmouth's Fifth Ward.

Portsmouth's first professional baseball team started in 1895. The Portsmouth "Truckers" played in the Virginia League until 1928.

The Spanish-American War in 1898 brought even greater activity and employment to Portsmouth's Navy Yard. One memorable event from the war occurred on May 27, 1889, when throngs of spectators rushed to the waterfront to see the Spanish cruiser Reina Mercedes, the only surviving vessel from Admiral Cervera's fleet at Santiago, Cuba. Grimes Battery, Portsmouth's well-known artillery unit, fired salutes as the giant ship passed, accompanied by 22 tugs with whistles blowing and flags flying.

Portsmouth grew from only 13,268 people in 1890 to 17,427 in 1900, and the city doubled in size to 1.4 square miles as Portsmouth expanded for the first time in over a century. With an increasingly large city to travel, perhaps it is not surprising that use of the automobile began to grow following the introduction of the first one to the city by Dr. George Carr in 1902.

With the growth of the United States through its increasing naval power, Portsmouth's Navy Yard in particular and the city in general gained national prominence. President Theodore Roosevelt came to Portsmouth in 1906, the same year The Great White Fleet came as it began its world tour from Hampton Roads. The Jamestown Exposition of 1907 also brought attention, visitors, and prosperity to Portsmouth.

Dramatic change came to Portsmouth's Naval Hospital on October 1, 1907 with the arrival of an order that the almost 80-year-old building had to be vacated within 10 days for a $200,000 renovation project. Tents lighted by electricity and heated by steam were the only shelter for patients during the bitterly cold winters before the building was again opened on February 17, 1909. Designed by architects Wood, Don, & Deming of Washington, D.C., the improvements provided modern bathrooms, multiple elevators, an operating room with ample sunlight, and other amenities for the 1830 structure.

Equally dramatic was a personnel change instituted by the Sixtieth Congress, which had authorized a Navy Nurse Corps. By October 1, 1909 there was one chief nurse supervising six others at the Naval Hospital. The nurses were paid $50 per month and given quarters on Court Street at the Waverly Apartments. A small café there provided their meals. As if female nurses taking on what had formerly been male jobs was not enough, a Dental Corps was established for the Navy in 1912 and dental services were soon offered at the Naval Hospital.

Portsmouth expanded yet a fourth time in 1909 by annexing Scottsville and Prentis Place as the city's Sixth and Seventh Wards. That year, Hampton Place was built by Dr. Parrish as the first modern real estate development in

Portsmouth. By 1910 the population had almost doubled from its previous impressive size in 1900, and the census reported 33,190 inhabitants.

A group of over 40 African-American students was transferred to the new High Street School—located in the True Reformers Building at 915 High Street—from Chestnut Street School. I.C. Norcom was the supervising principal while William E. Riddick was the principal. The students called it "Pepsi Cola College." Only nine of the students who started out in 1911 graduated with their class on June 16, 1915 as members of Portsmouth's first African-American high school class. Receiving their diplomas in ceremonies at Zion Baptist Church were Mamie L. Wright, Ula Mae Scott, Zena Sawyer, Effie Mae Sawyer, Lee F. Rodgers, Ethel Rodgers, Lubertha Montee Nichols, Mamie Cross, and James Campbell. Lee Rodgers, valedictorian of the class of 1915, later wrote the "Colored Notes" column for the newspaper.

In 1912, a new Municipal Building was constructed just north of the 1846 Court House. The Students Club organized the Portsmouth Public Library, and space was made available at the rear of the old 1846 Court House. The Seaboard Air Line Railway and the YMCA enlarged the collection by donating their private libraries, and the library opened on December 1, 1914.

In 1916, the city manager form of government was adopted to provide professional management of the growing city. T.B. Shertzer became the first city manager that December.

On November 11, 1916, the final performance of "William F. Cody's Wild West" was held in Portsmouth. "The Grand Finale" was staged near the intersection of Washington and Lincoln Streets, and the closing of "Buffalo Bill's" traveling show seemed to herald the ending of one era and the beginning of a new age for the nation and for Portsmouth as the United States entered World War I.

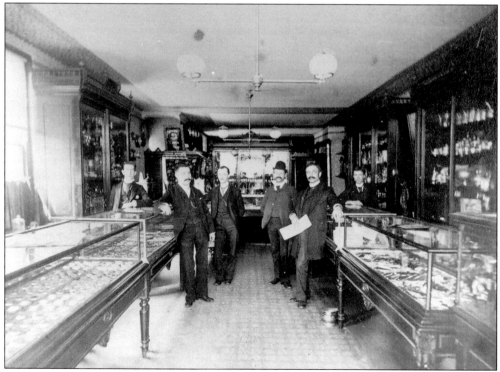

R.W. Chapman's jewelry shop featured gas lamps and a brass spittoon in 1900. Chapman wears a derby, and to his right is E.F. Jakeman. To his left and behind the counter is William Deans. (Courtesy Portsmouth Public Library.)

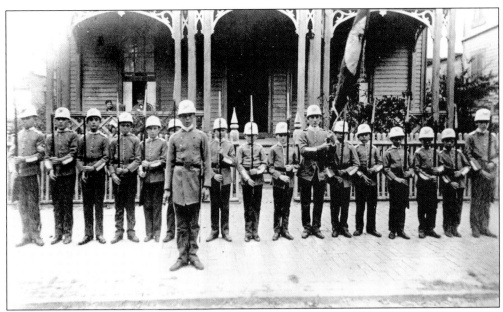

In 1890, young boys of the Portsmouth Junior Rifles stand in front of Charles Nash's home. War would not come to Portsmouth in this era, but a monument in the Crawford Street median near North Street recalls the valor of its men who went to fight in the Spanish-American War, the Boxer Rebellion, and the Philippines during this period. (Courtesy Portsmouth Public Library.)

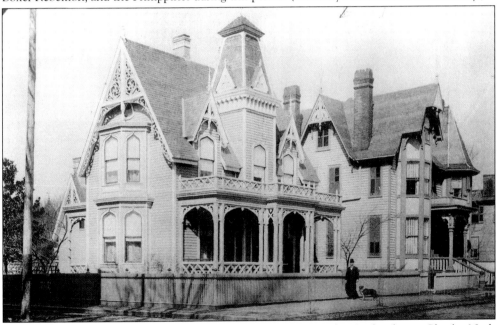

This 1895 photograph shows the beautiful ornamentation on the Gothic home Charles Nash built on the northwest corner of Middle and Glasgow Streets for himself in 1880. He built the house with asymmetrical towers next door for his sister, but the second home was better known as the Eastwood house after the name of the family who bought it later. The Nash-Gill house features three different designs in its slate roof, and the ornamentation on the rear and back is as elaborate as that on the front of the home. (Courtesy Portsmouth Public Library.)

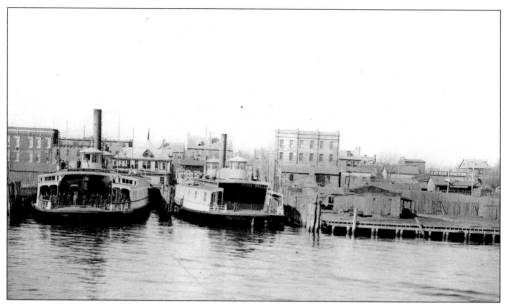

Portsmouth is seen with ferries in dock in 1895. A modern steam ferry, the *Gosport*, was built in 1832 at a Portsmouth shipyard. Later the ferries *Portsmouth*, *Union*, and *Norfolk* likewise provided five-minute service to nearby Norfolk and Berkley. The most famous ferry of the late 19th century was the side-wheeler *Manhassett*, bought in 1874 and fitted with an upper deck with a latticework fence. Nursemaids, babies, and small children could ride the cool upper level for 25¢ per party and the ship became known as the "Nanny Ferry." (Courtesy Portsmouth Public Library.)

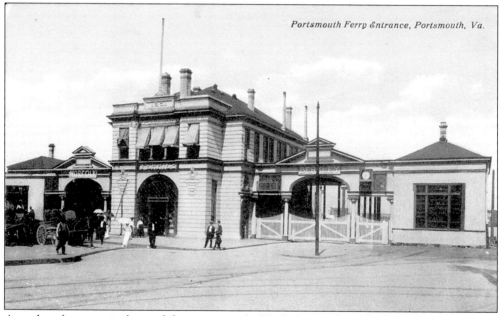

A modern ferry terminal graced the eastern end of High Street where the ferries landed. Berkley was an independent city to the south of Norfolk, though it is now part of Norfolk. Vehicles entering to the left went to Norfolk while those entering to the right went to Berkley. (Courtesy Portsmouth Public Library.)

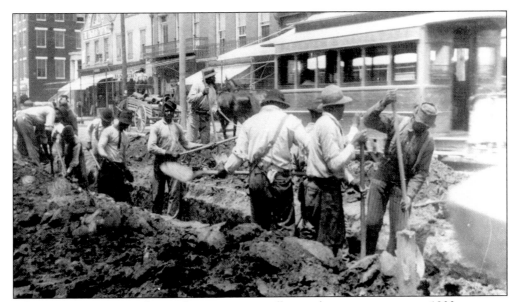

African-American men dig up the street to install a modern sewer system *c.* 1900, a system that is still impressive since the pipes are at, or sometimes below, sea level. New Orleans and Portsmouth are among the few cities that sport this type of pumping system. Horse-drawn streetcars, such as the one behind the men, began running *c.* 1885 and electrical streetcars started running in 1889. The streetcars connected downtown to Park View and the Naval Hospital. (Courtesy Portsmouth Public Library.)

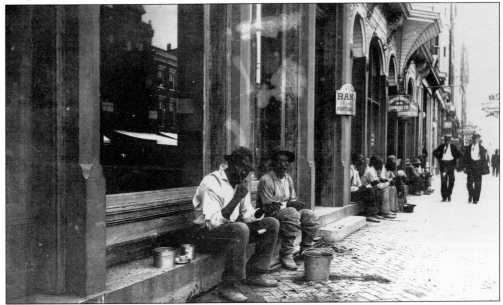

Finding a place to sit for a meal on a sunny day, these African-American workers pause along the south side of High Street between Middle and Crawford Streets. A calendar in the window indicates this sunny day was in July of 1895, and the signs on the doorways indicate that the Bank of Portsmouth (later the American National Bank) and the United States Express Company were located here. The herringbone-pattern brickwork was restored to the first seven blocks of High Street in the 1980s. (Courtesy Portsmouth Public Library.)

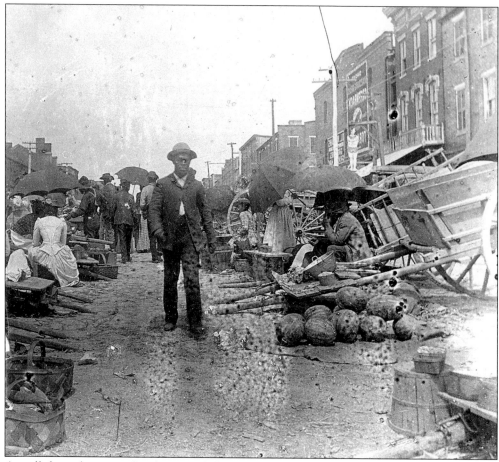

A well-dressed man walks the crowded market stalls at County Street c. 1900. Note the many opened parasols the ladies have raised to keep cool on that warm, sunny day. (Courtesy Portsmouth Public Library.)

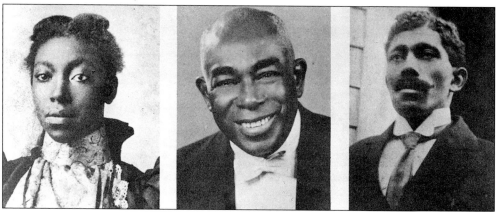

Pauline Hinton Jackson and her husband, Graham Washington Jackson, are shown in photographs of this era. Their son, Graham Washington Jackson, would become famous when a *Life* magazine photograph showed him as the grief-stricken accordion player when President Franklin D. Roosevelt died. (Courtesy Portsmouth Public Library.)

Matilda Sissieretta Joyner Jones (c. 1868–1933) was called "Black Patty" after her debut on the New York stage because she was compared to a leading opera star of that time, Adelina Patti. She was nationally known and performed at the White House. For 19 years, her Black Patti Troubadors entertained African-American audiences and the Republic of Haiti gave her a gold medal. (Courtesy Portsmouth Public Library.)

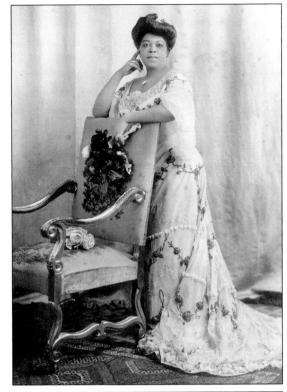

The desire to be modern is demonstrated in the sign for "Up to Date Groceries" which are promised on the cart in the background. By contrast, a woman with an old-fashioned sunbonnet rests on one of the many carts in the marketplace at the 100 block of South Street in 1895. (Courtesy Portsmouth Public Library.)

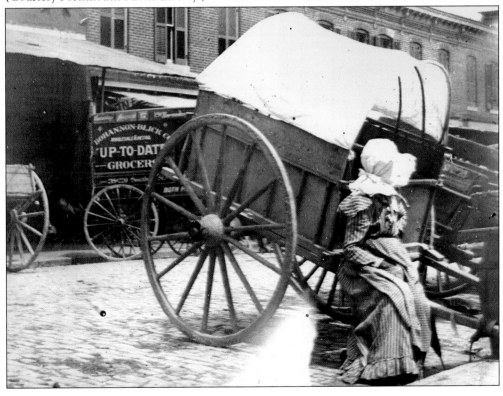

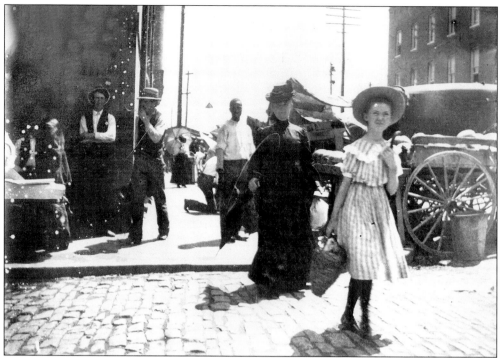

A young girl in black stockings and a woman dressed from head-to-toe in black show the Victorian styles of dress that were fashionable in 1901. This scene shows the market near the South end of Middle Street. (Courtesy Portsmouth Public Library.)

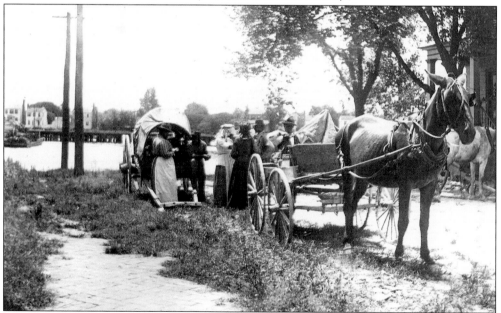

Just a little further south along Middle Street at South Street, citizens shop at a market wagon in 1901. Gander Creek (sometimes called Crab Creek) can clearly be seen as a broad waterway that separated the oldest part of Portsmouth from nearby Southside (sometimes called Newtown). (Courtesy Portsmouth Public Library.)

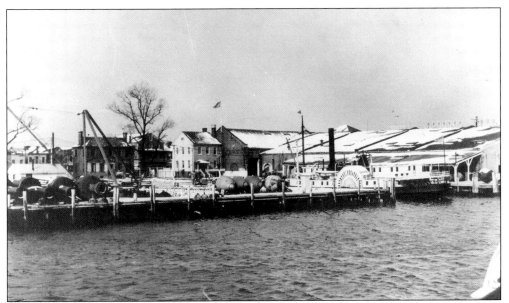

On the other side of Gander Creek was Southside and its eastern riverfront was dominated by the Coast Guard base. In this scene from the turn of the century, a side-wheeler vessel is in dock and the massive buoys placed to mark channels sit nearby. The large house by the flagpole was the home where Marine Corps commandant Neville was raised. It was built in the 1700s and destroyed in 2001 when the area was cleared for a large yacht repair facility. (Courtesy *Virginian-Pilot and Ledger-Star.*)

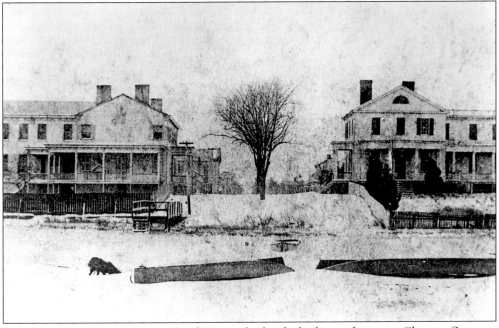

The Watts House and the Pritchard House, both of which are shown in Chapter One, are featured on their original sites west of the tidal marshes that cut into Dinwiddie and Washington Streets. After Margaret Watts sold the land to Dr. Charles Parrish in 1908, the homes were moved and Hampton Place was developed on the site. (Courtesy Portsmouth Public Library.)

At the northwest corner of Middle and London Streets, this home was built c. 1885 on the former site of the Presbyterian Church. It housed the Ballance School of Dance when Jean and Rudy Guest lived there from 1957 to 1994. It features a Federal doorway, wrought-iron porches, and massive chimneys. The Odd Fellows Hall can be seen to its immediate right and this building, today the three-story Colonial Apartments, was still only two stories high when this picture was taken in the 1890s. The Forsythe house next door was built about 1800. The Watts family later owned it and built the homes to the right for their sons, Dr. Edmund M. Watts and Judge Leigh R. Watts. (Courtesy Portsmouth Public Library.)

This grand example of Victorian architecture still stands at 218 North Street. It is difficult to convey the effect of its massive architecture and it ornamentation in bright gold, blue, and green. A color photograph of the home appeared in the National Geographic Society's pictorial survey of Hampton Roads in July of 1985. (Courtesy Portsmouth Public Library.)

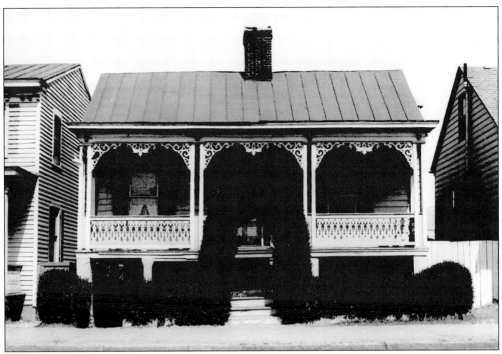

This small Victorian home was photographed in April of 1932. Referred to as the Frank Wyatt House on Second Street, it was located in the Southside (sometimes called Newtown) section of the city near the shipyard. It was torn down in 1956. (Courtesy Portsmouth Public Library.)

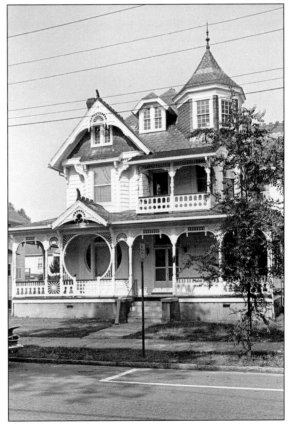

The Thomas L. Cleaton House at 200 Hatton Street still showed its charm in this June 1966 photograph. Because many historic homes were deteriorating at that time, the City Council authorized the Portsmouth Redevelopment and Housing Authority to create the first two conservation districts in the state of Virginia—Olde Towne (VA-R-49) and Park View (VA-R-48). For details, see the author's 1993 dissertation, *The Implementation of Public Urban Neighborhood Conservation Projects: A Comparative Case Study of Portsmouth, Virginia, 1960–1990*. (Courtesy *Virginian-Pilot and Ledger-Star*.)

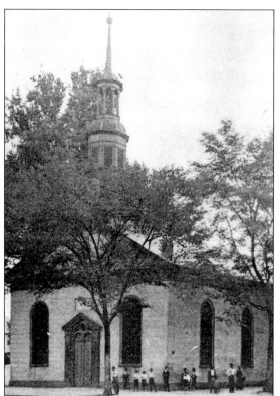

In 1892, Trinity Episcopal Church featured a fancy steeple and white picket fences at the southwest corner of High and Court Streets. Originally established as Portsmouth Parish church in 1761, its original vestry included city founder William Crawford. Trinity's cemetery holds the remains of many distinguished people from Portsmouth's early history, including Commodore James Barron and Bernard Magnien, an aide to Lafayette who remained in Portsmouth after the Revolution. (Courtesy Portsmouth Public Library.)

In 1895, St. Paul's Roman Catholic Church graced the northeast corner of High and Washington Streets. The structure shown here was started in 1860 but not completed until 1868. A cathedral-style building was constructed in 1895–1905 that replaced this fine structure. (Courtesy Portsmouth Public Library.)

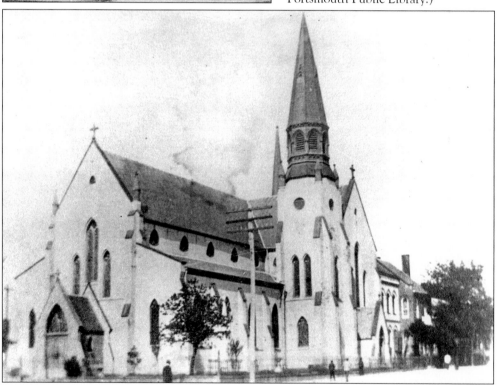

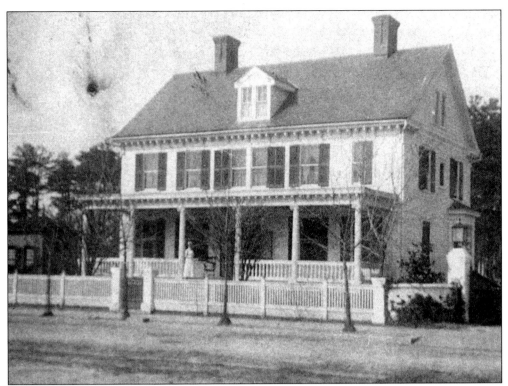

The King's Daughters Hospital at 824 Emmett Street was established following the purchase of this fine home of Dr. William Shmoele in 1903. An earlier hospital of the same name had been at 49 Court Street, and both structures took their name from the group that promoted the creation of a modern hospital in Portsmouth, the Daughters of the King ladies' auxiliary of Trinity Episcopal Church. This photograph was taken by H.H. Downing. (Courtesy Portsmouth Public Library.)

Replacing a previous Court Street Baptist Church building that also stood on the northeast corner of Court and Queen Streets, the current building opened in 1901. It is a fine example of Byzantine-Romanesque architecture, and its ornate towers and pink granite walls are unusual for a Baptist church. This photograph is from the 1950s. (Courtesy Portsmouth Public Library.)

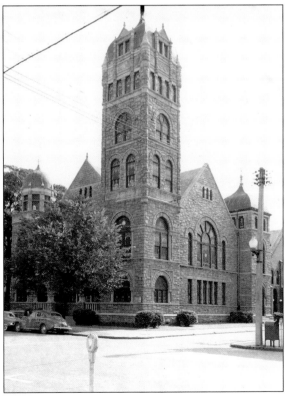

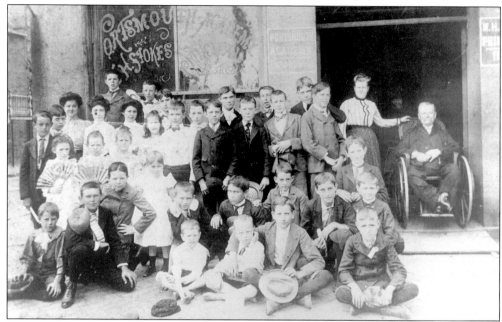

Children of Portsmouth Academy posed in 1901 near teacher Miss Emma Stokes and her brother, W.H. Stokes, who founded the school in 1868. This private school was not related to the Portsmouth Academy founded on Glasgow Street in 1825. (Courtesy Portsmouth Public Library.)

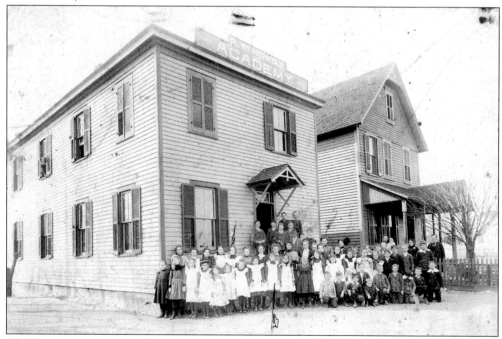

Children at the Port Norfolk School are shown c. 1900. Prentis Place was annexed in 1909 and Port Norfolk became part of Portsmouth in 1919. By 1920, the number of residents in Portsmouth had reached 54,387—over three times its population in 1900—and its size was 5.8 square miles. (Courtesy Portsmouth Public Library.)

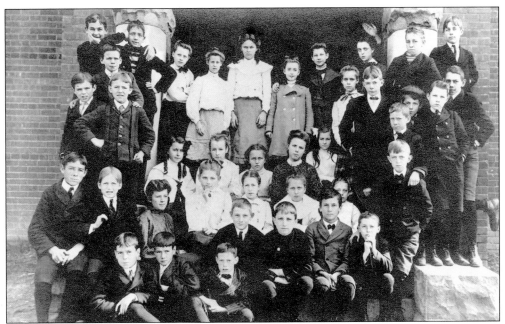

Miss Bessie Woodard's fifth-grade class at Cooke Street School posed for this picture in March of 1904. The students were, in alphabetical order, Bessie Aherron, Ed Allen, Reggie Allen, Julia Barksdale, Agnes Bunkley, Frank Campbell, Bascom Dey, Eddie Eller, Vernon Euler, Marcy Ferebee, Hope Garner, Estelle Gwynn, Shirley Hope, Carrie Land, John Long, Eva McDonald, Hattie Manning, Herbert Manning, Ching Maynard, Graydon Meginley, George Morrison, Richard Mules, Fred Nelson, Eugene Nichols, William Owens, Sallie Persons, Elton Rea, Amanda Rice, Pearl Rice, Mary Salisbury, Claud Schools, Lee Shannon, Edwin Staples, Willie Sterling, Harry Stewart, Eva Tabb, Christine Tyson, Emma Wyatt, and Jennie Young. (Courtesy Portsmouth Public Library.)

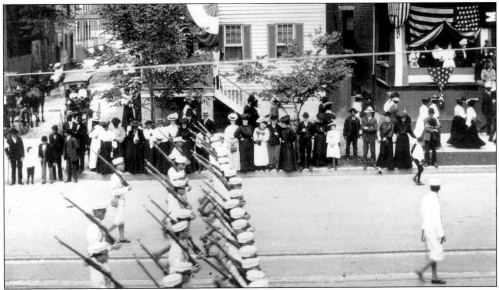

When President Theodore Roosevelt visited Portsmouth in 1906, the citizens decorated their homes and turned out for the gala parade. (Courtesy Portsmouth Public Library.)

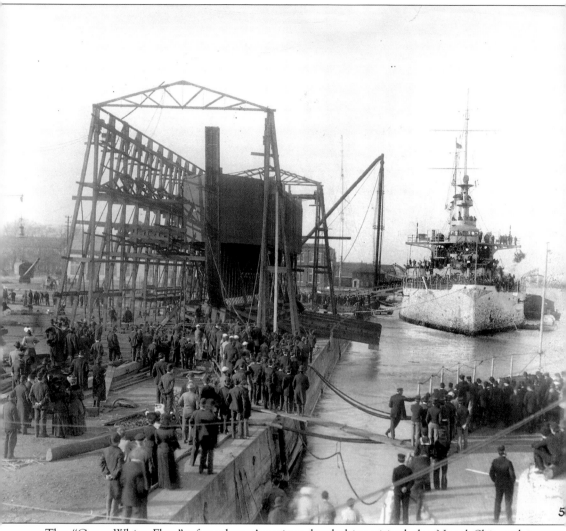

5

The "Great White Fleet" of modern American battleships visited the Naval Shipyard in 1906. The first such steel-hulled warships in the United States Navy, the cruiser *Raleigh* and the battleship *Texas* were built in Portsmouth's shipyard and launched in 1892. (Courtesy Portsmouth Public Library.)

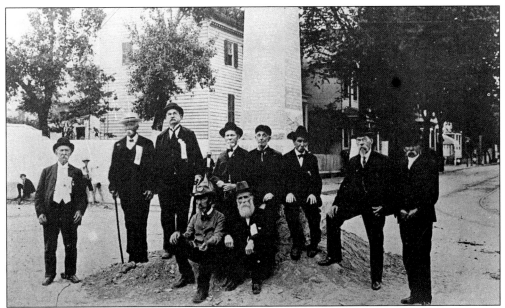

Veterans of Grimes Battery who had fought for the Confederacy appear at this June 8, 1906 dedication of the Portsmouth Light Artillery Monument. Pictured from left to right are (standing) Capt. John H. Thompson, George W. Brent, and Wilson B. Lynch; (sitting) John W. Crismon, W.W. Newby; (behind those sitting) M.W. Allen, C.E. Ironmonger, J.W. Griffin, F.J. Nicholson, and C.E. Warren. (Courtesy Portsmouth Public Library.)

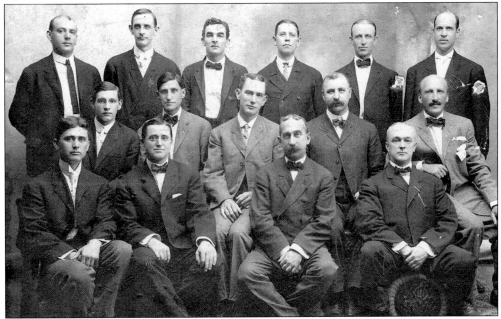

Members of the Retail Merchants Association c. 1900–1910 are shown here. From left to right are (front row) A.B. Jarvis. T.S. Lawrence, Nathan Levy, and William Chapman; (middle row) William Hodges Baker, B.F. Hofheimer, John A. Morris, Mr. Armentrout, and E. Anthony; (back row) S.T. Hanger, E.W. Maupin Jr., W.F. Robertson, J.W. Booth, E.D. Clements, and Maurice (last name illegible but begins with an A). (Courtesy Portsmouth Public Library.)

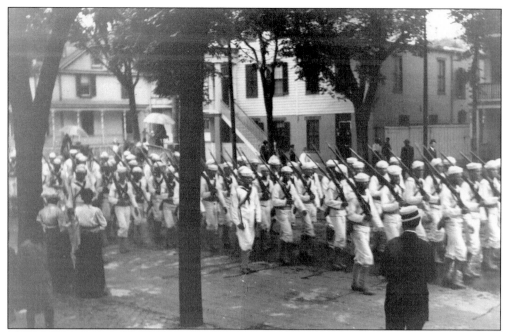

Though there were modern buildings in the city, much of what is now a highly commercial corridor was still largely residential in 1911 when these sailors marched east. This picture shows the north side of High Street at Dinwiddie. (Courtesy Portsmouth Public Library.)

Just west of Trinity Church on the south side of the 400 block of High Street, a bicycler passes a carriage in front of a Victorian home and a gambrel-roofed dwelling built about 1785. The Emmerson family owned both homes in 1910 when this photo was taken, and now the Commodore Theater occupies the site. (Courtesy Portsmouth Public Library.)

Across the street, the YMCA stood on the north side of High Street just beyond the 1846 courthouse. The building was the site of the popular Colony Theater in the 1940s through the 1960s and it still survives as apartments at the time of this writing. The steeple at the top left is that of Monumental United Methodist Church on Dinwiddie Street. The photograph is from 1912. (Courtesy Portsmouth Public Library.)

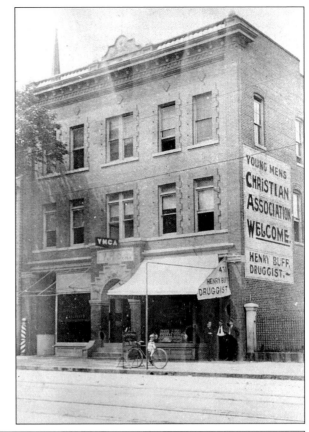

To make the city seem more modern, the image of a car has been inserted in this view of the 1846 Court House. Between the streetcar tracks which ran along High Street is a small station. The 1912 Municipal Building is just behind the station in this northwestern view of the intersection of High and Court Streets. (Courtesy Portsmouth Public Library.)

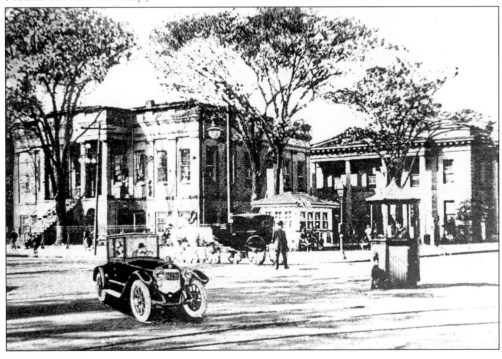

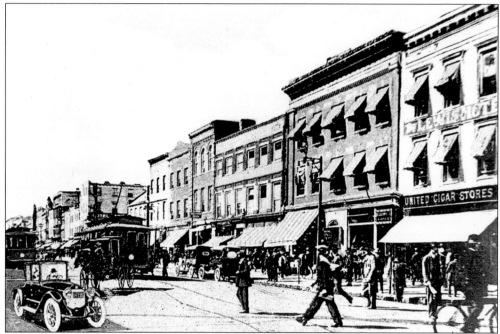

By 1915, the city was filled with activity. The trolleys in the background had been electrified *c.* 1900 and modern commercial buildings bustled with activity, as shown in this view west along High Street from the Ferry Landing. Dr. George Carr brought the first automobile to the city in 1902, but the car shown here was added by the postcard's publisher to make the city seem more up to date. (Courtesy Portsmouth Public Library.)

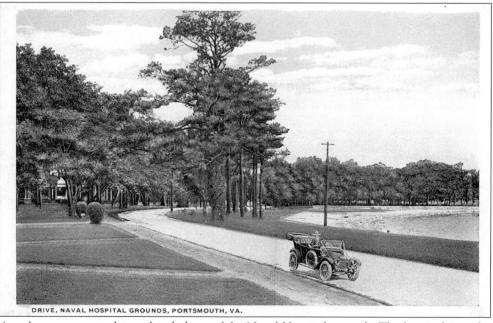

DRIVE, NAVAL HOSPITAL GROUNDS, PORTSMOUTH, VA.

A real car appears in this undated photo of the Naval Hospital grounds. The hospital is to the left and hidden by the trees. During 1907–1909, the hospital underwent major renovations designed by architects Wood, Don, and Deming of Washington, D.C. (Courtesy Al Cutchin.)

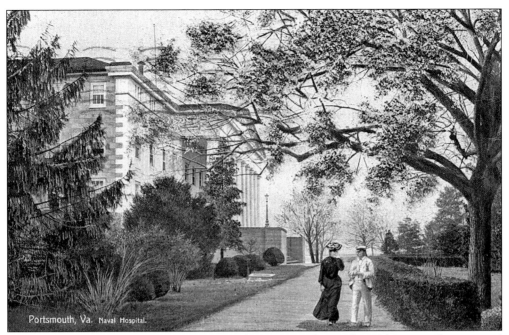

The grounds of the Naval Hospital were a pleasant area for strolls, as shown in this postcard sent in 1911. The neighborhood west of the hospital was named Park View because it afforded such a pleasant view of the hospital's landscaped park. (Courtesy Al Cutchin.)

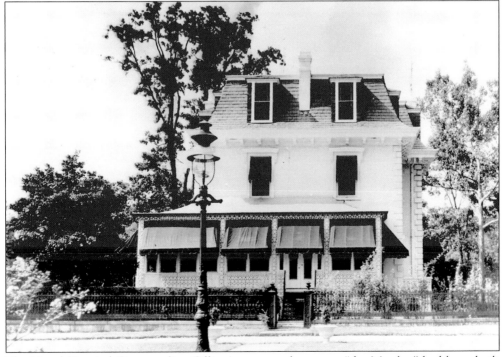

The Naval Hospital Commanding Officer's quarters, known as "the Myrtles," had been built in 1857 but it was modernized in 1900 by adding a new top floor. It was razed in 1956 to make room for the new Naval Hospital. (Courtesy Portsmouth Public Library.)

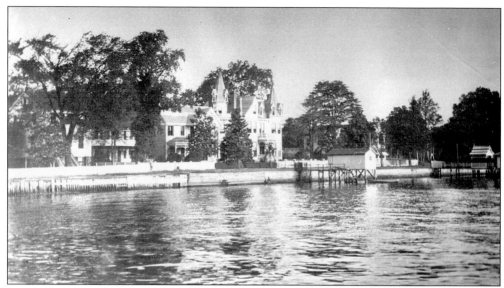

Swimming Point was a fashionable place in 1912, as witness the tall peaks of the Victorian mansion shown in this picture. Boathouses extend into what is now know as Crawford Bay, named in honor of William Crawford who gave the lands for Portsmouth to be a town in 1752. (Courtesy Portsmouth Public Library.)

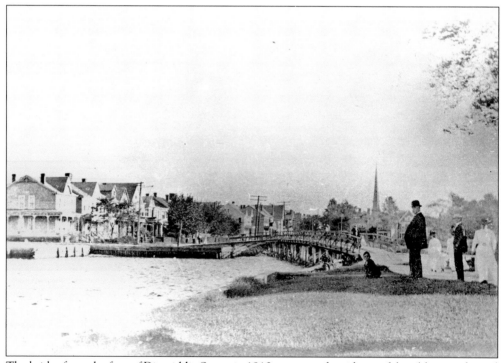

The bridge from the foot of Dinwiddie Street in 1912 connected residents of the oldest residential area to the neighborhood of Swimming Point and to the Naval Hospital. Because this was the only route to the only gate at the Naval Hospital, Congress had appropriated $5,000 in 1904 to replace the former dilapidated bridge with this one. (Courtesy Portsmouth Public Library.)

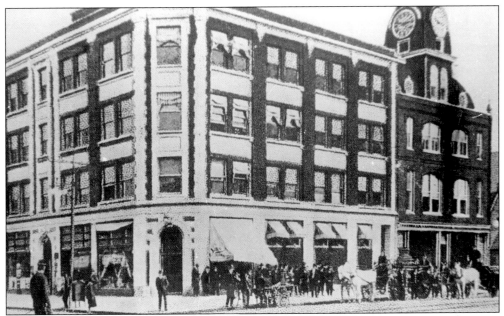

Horse-drawn fire trucks stand in front of the fire station at the base of the Municipal Building, which still stands to the right of The New Kirn Building. The New Kirn Building was constructed in 1911 on the site of the former post office at the southeast corner of High and Court Streets. (Courtesy Portsmouth Public Library.)

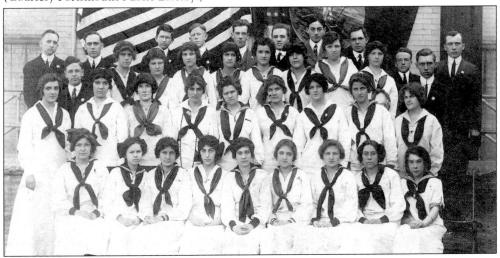

Portsmouth High School's class of 1914 posed for this patriotic picture. From left to right are (first row) Amelia Bain, Hattie Curbing, Ruth Ballentine, Doris Porter, Mary Dorsey Downey, Nan Stewart, Annie Palmer, Louise Van Patten, and Marian Whitehurst; (second row) Dorothea Ward, Annie Laycock, Fanny Rawls, Flo Hope, Helene Nichols, Lorraine Cadmers, Lilian McMahon, Ellen Lash, and Eloise Weaver. Leckie Ewald, Sallie White, Nell Niemeyer [undecipherable] Moffatt, Peggy Wanycott, Charlotte Robertson, Marie Hodges, Alice Moore Armstrong, Evelyn Brooks, Walter Hinton, Leroy Riddle, and Miles Duval; (third row) Tom Oast, Marshall Bland, Tony Weaver, Elihu White, Douglas Parker, Arthur Wilkins, and Louie Fass. Principal J. Leon Codd is fifth from the right on the back row. (Courtesy Portsmouth Public Library.)

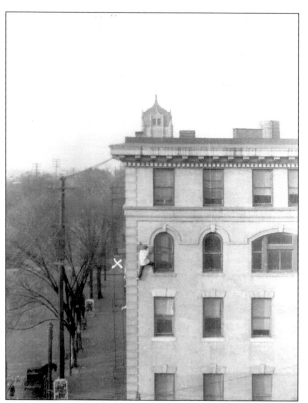

A precarious perch indeed faced this "human fly," a man scaling the Hotel Monroe on February 23, 1915. A large crowd gathered at the northeast corner of High and Court to watch him scale the building without a safety harness or net. Beyond the hotel is the distinctive tower of Court Street Baptist Church. (Courtesy Portsmouth Public Library.)

The police department had obtained a modern vehicle when this photo was taken in *c.* 1914. The emergency vehicle was capable of serving as an ambulance or as a "paddy wagon." The little boy at right stares admiringly as the officers show their obvious pride. (Courtesy Portsmouth Public Library.)

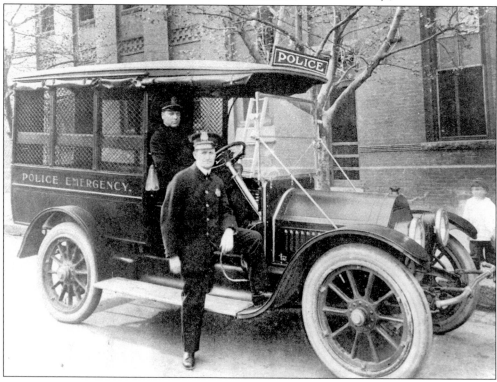

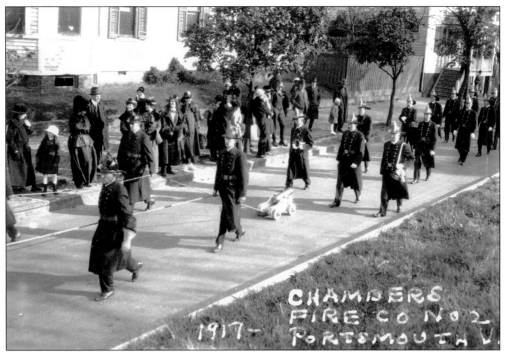

Chambers Fire Company Number 2 marches north along the east side of Washington Street in 1917. The small cannon seen in the center of the photo could be used for signals or salutes. (Courtesy Portsmouth Public Library.)

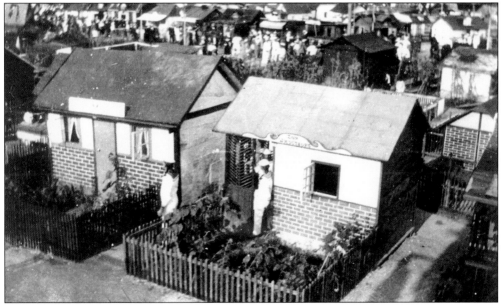

The German Village at the Naval Shipyard was built by about 1,000 German sailors interned at the naval shipyard in 1915. These men from the Prinz Eitel Frederick and Kron Prinz Wilhelm built a miniature replica of an Alpine Village that drew large crowds. The public paid 10¢ apiece to see the novelty and to benefit the Red Cross. (Courtesy Portsmouth Naval Shipyard Museum.)

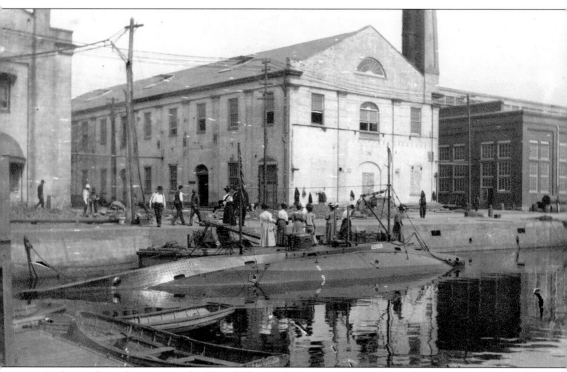

Ladies and gentlemen tour the Naval Shipyard, inspecting a modern submarine on visitors' day in 1906. The USS *Adder* was to be matched shortly by U-boats from Germany and the United States would find itself brought into World War I as Portsmouth entered a new era. (Courtesy Portsmouth Public Library.)

Four

WORLD WAR I AND WORLD WAR II

While some of Portsmouth's men went off to fight with the American Expeditionary Force in Europe in 1918, other men and women supported the war effort at the Navy Yard. Shipyard employment swelled from 2,718 workers in June 1914 to 11,234 in February 1919. Three new drydocks were completed in 1919, and this new capacity allowed the Navy Yard to build 24 new ships, including 4 destroyers, by the end of that year.

To house the growing number of shipyard employees, the newly created United States Housing Corporation approved two developments in 1918. Truxtun and Cradock became the first two planned communities in the United States since they included shops, churches, and houses in a neighborhood designed by experts. Cradock was three miles south of the Portsmouth city limits, and Truxtun was only partly in the city. Both were later annexed.

Truxtun, the African-American community, was located on Key Road, now called Portsmouth Boulevard, just three-eighths of a mile west of the Navy Yard near its intersection with Deep Creek Boulevard, a road that took residents to the commercial area of Portsmouth. Streets were designed to run east-west so as to take advantage of the prevailing breezes. Truxtun opened its 250 five-room houses on May 25, 1919, and by July, 183 of them were rented, even though Truxtun's commercial area was never developed. After the war, two African-American businessmen bought the development and resold the units. The primary buyers were those people who already rented the homes.

For white workers, Cradock was built on what had been the 310-acre Afton Farm just south of the Navy Yard. Cradock's streets were shaped like an anchor with a main street being the anchor's shank, and the streets were named alphabetically, bearing the names of naval heroes such as Decatur and Faragut. At the center was Afton Park, with shops and a park where concerts were played. By the Armistice, only 759 of the planned 1,225 homes had been completed.

With the close of the war, Portsmouth annexed Port Norfolk in 1919. Adding this immense area increased the city from 2.4 square miles that held 33,190 people in 1900 to 5.8 square miles that were home to 54,387 residents. Originally developed as a resort area with its riverfront beach, Port Norfolk was also the home of the popular educational events called Chatauquas at that time. Chatauqua Avenue still retains the name of those bygone entertainments from the days when Port Norfolk was the city's playground.

The recession of the 1920s followed the demobilization of armies and greater unemployment, although Portsmouth was somewhat protected for a while by having the Navy Yard as its chief employer. The shipyard began work on conversion of the collier Jupiter into the USS Langley, the nation's first aircraft carrier, which was commissioned on March 22, 1922. Construction on the battleship North Carolina was halted in 1923 by the Washington Naval Limitation Treaty, and other national cutbacks reduced the Navy Yard employment figures to only 2,538 by the end of 1923.

A battleship modernization plan began in 1925, but that flurry of activity was tempered by the onset of the Great Depression when the stock market crashed in 1929. The 1930 census showed the population had shrunk to only 45,745.

Fortunately, the Navy Yard was directed to build nine destroyers as part of the National Industrial Recovery Act of 1933 along with other government programs. Rear Admiral Manly H. Simon, commander of the Navy Yard

from 1937 to 1941, helped the facility gear up for war as Europe edged towards another world war that began in 1939. He predicted shipyard employment would reach 4,000 and chided Portsmouth leaders to provide housing. He was incorrect by a factor of ten for peak employment reached 42,893 in February of 1943.

Simon is quoted as having said that "I hope I will be here long enough to build a city." Due in part to his efforts, 2,500 trailers in fields at the edges of the city as well as 45 public and private housing developments sheltered the growing population. At least 16,437 units were created, including Barlow Place , New Gosport, Portsmouth Heights, Westhaven Park, Williams Court, Williams Court Apartments, Wendell Neville Dormitories, and Simonsdale. In later years many of these quickly-erected dwellings were taken down, but Simonsdale had better housing and is still a vibrant neighborhood that bears Rear Admiral Simon's name.

Portsmouth was filled to overflowing, and many private homes took in boarders. Some rooming houses rented beds in eight-hour shifts. Portsmouth Housing Authority, which had been created on September 13, 1938, opened all of Dale Homes and part of Swanson Homes to house the increasing World War II population. These were the first two public housing projects in Virginia, and after the war they became homes for low-income people as originally intended.

During the war, the Navy Yard more than doubled its size to 746.88 acres. By the end of World War II in 1945, it had built 21 major ships and completed work on 6,850 naval vessels. Its work helped make victory possible, and its growth helped revive Portsmouth.

During this era, the city added its first motorized buses in 1935 and its first radio station, WSAP, in 1942. Maryview Hospital was founded on High Street not far from the Churchland Bridge in 1944, and in 1948 Waterview, the community beside Maryview Hospital, was annexed along with another growing neighborhood, Westhaven, to its southwest. The city that had a population of 50,745 in 1940 had increased its population by almost 60% by the end of the decade. As the 1950 census showed, Portsmouth extended over 9.7 square miles and had reached a population of 80,039 as the long period of world wars and deprivation came to an end.

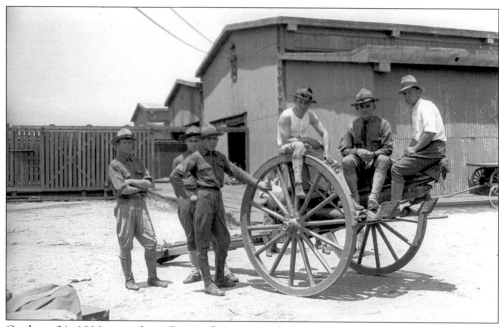

On June 24, 1916, men from Grimes Battery are shown getting ready to join Gen. John J. Pershing's command for a campaign against Pancho Villa in Mexico. Little did they know that in only a few years they would be serving under General Pershing again but this time in Europe's 29th Division during the Great War. This scene shows them at the Seaboard Air Line Railroad warehouses near the foot of North Street. (Courtesy of Murdaugh Collection.)

Among other events, the German U-boat's sinking of the *Lusitania* in 1915 followed by the February 1917 torpedo of the United States *Housatonic* and the Cunard liner *Laconia* brought America into World War I. Here, members of Shop 31 have shown their patriotism by raising a large amount to buy bonds to finance the war. The sign conveys the feelings of the time against the terror inflicted by the German submarines. (Courtesy of the Portsmouth Naval Shipyard Museum.)

The shop masters posed for this 1918 photograph during World War I. From left to right are (front row) Tyler, Sadler, Powers, Stanley, Bullard, Luck, Gwynn, Lamour, and Webb; (back row) Pendleton, Kneeburg, Lewis, Kiley, Gallagher, Volk, Morecock, Boole, Shannon, Lee, Bond, and Barclay. (Courtesy of the Portsmouth Naval Shipyard Museum.)

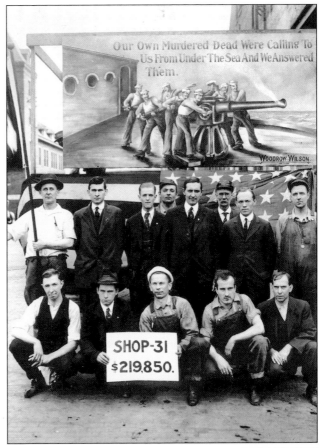

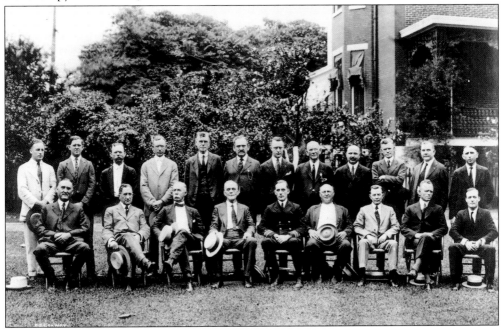

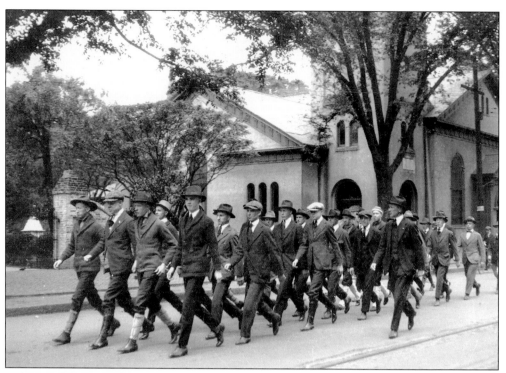

Young men marched south on Court Street in 1917. Only a few had uniforms, though it is obvious that they were enthusiastic about entering military service. (Courtesy Portsmouth Public Library.)

Distinguished for his service as a colonel with the Fifth Regiment during World War I, Wendell Cushing Neville was promoted to the rank of general and then, on March 15, 1929, became commandant of the United States Marine Corps. (Courtesy Portsmouth Public Library.)

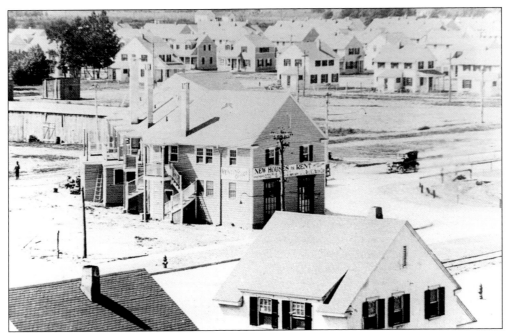

As wartime employment in Portsmouth's Navy Yard peaked at 11,234, the United States built two housing developments. Cradock, shown here, was the first planned community in the United States, featuring a modern shopping area within its center and offering a short walk to the shipyard for workers. Cradock was built for white employees and Truxtun was created for African-American workers. (Courtesy Portsmouth Public Library.)

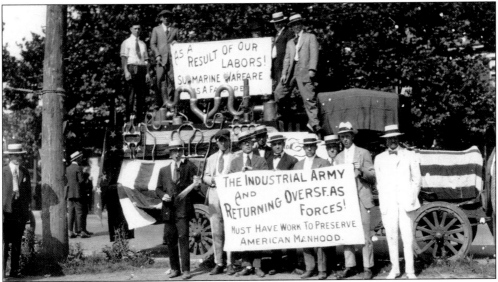

The end of the war brought a desire for normalcy and a need for jobs as thousands were discharged from the military and as the shipyard downsized. Shown here is a demonstration for jobs "to preserve American manhood" for the men who built the ships that made submarine warfare by the Germans a failure in World War I. Employment at the shipyard had dropped from about 11,000 in 1919 to only 2,538 by the end of 1923. (Courtesy of Portsmouth Naval Shipyard Museum.)

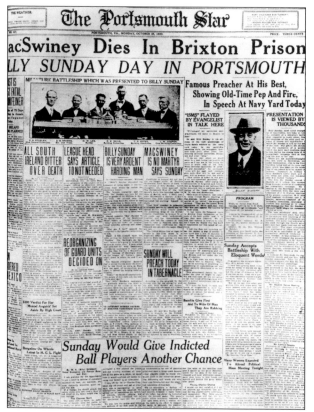

The Portsmouth Star

PORTSMOUTH, VA., MONDAY, OCTOBER 25, 1920. PRICE: THREE CENTS

acSwiney Dies In Brixton Prison

LY SUNDAY DAY IN PORTSMOUTH

Famous Preacher At His Best, Showing Old-Time Pep And Fire, In Speech At Navy Yard Today

Sunday Would Give Indicted Ball Players Another Chance

Billy Sunday, a famous evangelist of that time, came to the Naval Shipyard on October 25, 1920 and spoke against sectional pride. "I can see about as much sense in a man loving his country in parts as I can see in loving the north or south side of his wife." He spoke in favor of baseball, "the best, the manliest, the most distinctly American sport under the sun," as the *Portsmouth Star* quoted him as saying. Shown with the model battleship the shipyard presented him are C.S. Stublen (chair of the general committee), A.B. Sparks (secretary and treasurer), H.W. Lee (builder), R.E. Davis and T.D. Roper of the building committee, and J.W. Cooper (chair of the building committee). (Courtesy of the Portsmouth Naval Shipyard Museum.)

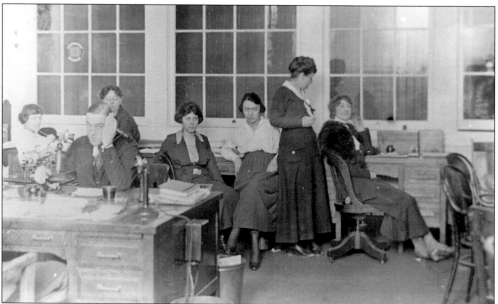

The general manager's office at the Naval Shipyard shows women had continued to be part of the workforce in the post–World War II era. Telephone service began in Portsmouth in 1884 with 22 subscribers and phones had become common by the time of this 1920 photograph. (Courtesy Portsmouth Public Library.)

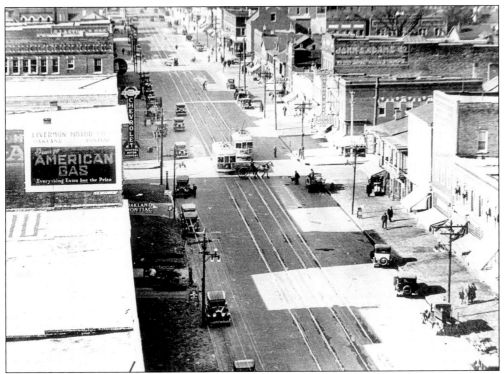

This undated photo shows downtown along High Street during the 1920s. William Crawford designed High Street wide enough for what would become many lanes for cars and trolleys to navigate by the time of this photograph. (Courtesy Portsmouth Public Library.)

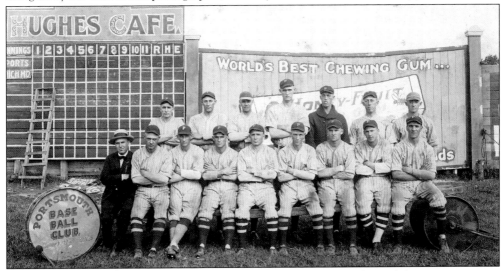

The Portsmouth Baseball Club posed in 1920 after defeating Richmond four games to one for the Virginia League Championship; they were received as heroes in a High Street parade. Standing from left to right are Parker, Greenea, Mangum, McCloughlin, Post, Frommholtz, and Senton. Seated at the left are Dawson, Champlin, Winston, Malonee, Vlox , Gudstree, Watt, Bangs, and Rooney. The team, nicknamed the "Truckers," survived until 1927. They are shown here in the Washington Street Ballpark. (Courtesy Portsmouth Public Library.)

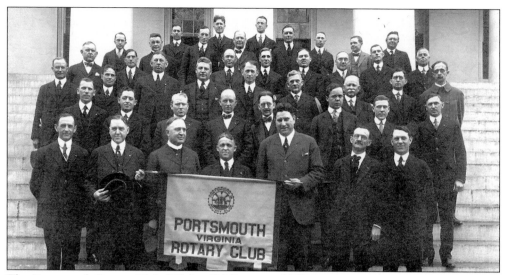

The Portsmouth Rotary Club (Club #476 District #760) was organized June 1, 1919 and had grown from 24 members to 54 by April 27, 1920. Pictured from left to right are (first row) E.W. Maupin Jr., Kemp Plummer, William A. Brown, B.B. Ferguson, and P. Coles Hutchison; (second row) P.B. Cole, W.B. Bates, C.C. Hall, E.D. Clements, Augustus M. Spong Jr., Robert B. Albertson, Marvin Cleaton, and J.H. Branch; (third row) Charles M. Meginley, A.M. Griggs, Charles R. Welton, A.C. Ogburn Jr., H.A. Hunt, F.T. Briggs, W.C. Corbitt, Paul F. Hanbury, and W.B. McEwen; (fourth row) Frank Lindsay, B.F. Hofheimer, J.S. Parker, L.M. Jack, Joseph Grice, H.F. Meyer, T.A. Brittingham, and Elder L. Lash; (fifth row) Samuel Kelly, J.F. O'Connor, S.B. Moore, J.C. Niemeyer, E.V. Bush, O.M. Creekmore, H.W. Mackenzie, and H.H. Dunn; (sixth row) C.E. Wise, William Stertzback, and Julius N. Dews.

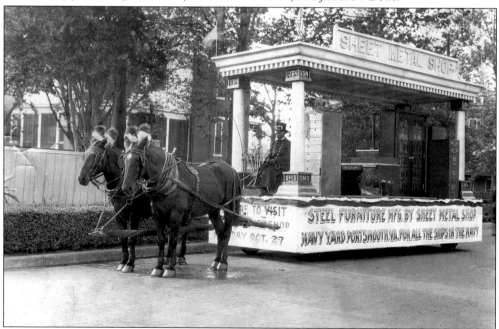

This parade float advised residents of Portsmouth to be sure to visit the Navy Yard's sheet metal shop on October 27, 1924. (Courtesy of the Portsmouth Naval Shipyard Museum.)

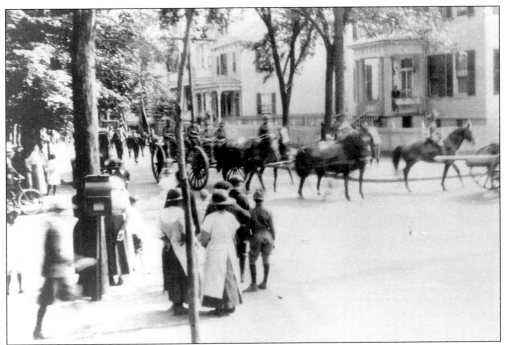

This picture of the Memorial Day parade in 1922 shows a horse-drawn caisson coming north along Middle Street and turning west on North Street. The boy at left is in the knickers style of pants, while the boy at the right is in a scout uniform that mimics the army uniforms. The girls wear pinafores—white aprons that can be changed easily when soiled—on top of their dresses. Everyone wears a hat. (Courtesy Portsmouth Public Library.)

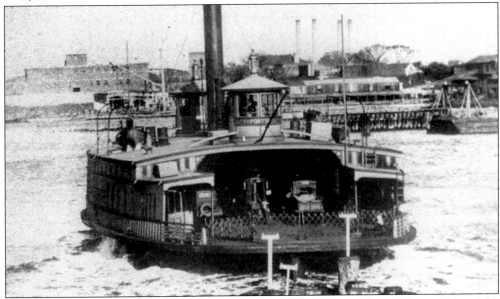

The ferry *City of Portsmouth* carried pedestrians and vehicles in the 1920s or 1930s. The ferries linked the citizens of Portsmouth and Norfolk and gave both cities downtown areas that remained robust until ferry service ended in 1955. (Courtesy of the Portsmouth Naval Shipyard Museum.)

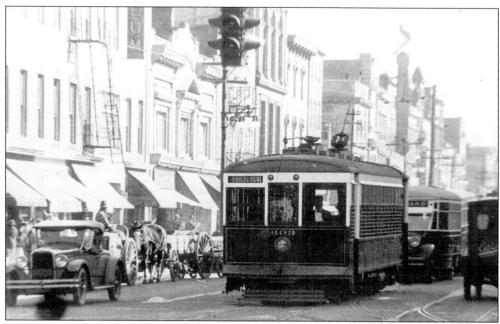

The streetcar to Pinner's Point is pictured with cars and two horse-drawn carts in this 1930s view of downtown. A modern stoplight hangs at the intersection, and by this time, neon signs appear on commercial establishments to give businesses a modern appearance. (Courtesy Portsmouth Public Library.)

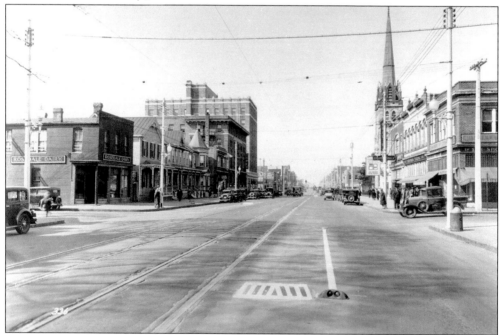

This picture shows High Street at the intersection with Dinwiddie in 1930. Rosedale Dairy at left was a major supplier of dairy products. The tall building at the left rear was the Professional Building at the southeast corner of Washington and High Streets. It was completed in 1929. (Courtesy Portsmouth Public Library.)

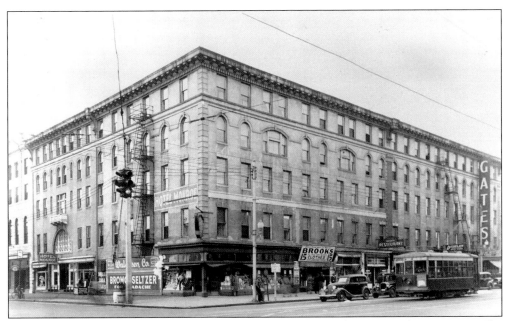

The Hotel Monroe (formerly the Ocean House) continued to be a major draw in 1938. The Gates Theater had opened and a Walgreen Co. Drugstore advertised Bromo Seltzer at the northeast corner of High and Court Streets. (Courtesy Portsmouth Public Library.)

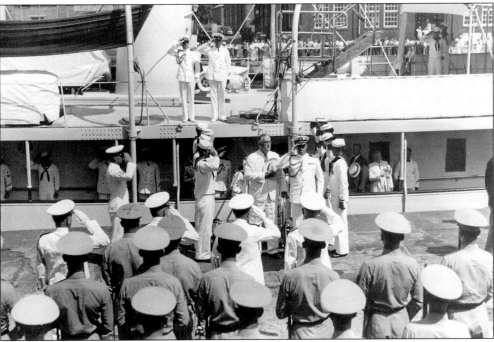

President Franklin D. Roosevelt visits the Naval Shipyard on July 29, 1940. His aide Capt. Daniel J. Callaghan, U.S.N., salutes at his side. The shipyard had contributed a first to naval history in 1929 by creating the first aircraft carrier, the USS *Langley*, from the collier *Jupiter*, and now it was again the center of attention following the start of World War II in Europe during September of 1939. (Courtesy Portsmouth Public Library.)

This is the Port Norfolk Aces Football Squad in the early 1930s. The team is shown at the South Norfolk Football field after winning by a field goal by Slick Mathias, better known as "Charley Rough." Players included Slick Mathias, Bruce Lawhon, Kirk Birtch, "Red" Whittaker, Frank Snyder, "Baby" Dowdy, Karl Martin, "Skinny" Wlliams, Hank Thompson, Dan Vick, Joe Pritchard, Ellis Engram, Charles Butler, Vance McKathine, Marvin Branagon, "Foxey" Meuss, Paul Birtch, Clifford Osborne, and Buck Mayland. Kirk Birtch was the coach. (Courtesy Portsmouth Public Library.)

Once again the nation called upon the shipyard to help provide victory at sea, and the shipyard workers rose to the challenge. Here, a bond rally engages workers' attention during World War II. Shipyard employment rose from 7,625 employees in September 1939 to an incredible 42,893 in February 1943, and the Navy Yard more than doubled its area to 746 acres. (Courtesy Portsmouth Naval Shipyard Museum.)

Shown here is the launch of the USS *Shangri La* at the shipyard on February 24, 1944. Portsmouth's Navy Yard constructed 101 ships and landing craft during World War II. Skilled workers built 30 major vessels, including 9 destroyers, in 1934–1939 and they completed repairs or other work on 6,850 naval vessels by the end of the war on September 2, 1945. (Courtesy Portsmouth Naval Shipyard Museum.)

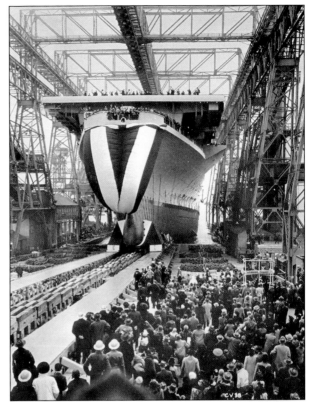

Workers await buses after work at the Naval Shipyard in 1944. Notice the gigantic scaffolding in the rear needed to build modern ships. During World War II, 16,487 family units were built in 45 projects. Many local families rented out rooms to support the war effort by giving shipyard workers and naval personnel a place to live. (Courtesy Portsmouth Public Library.)

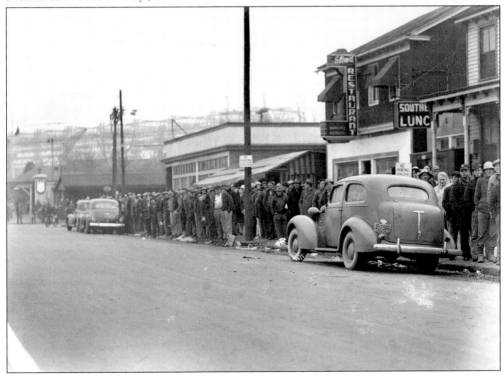

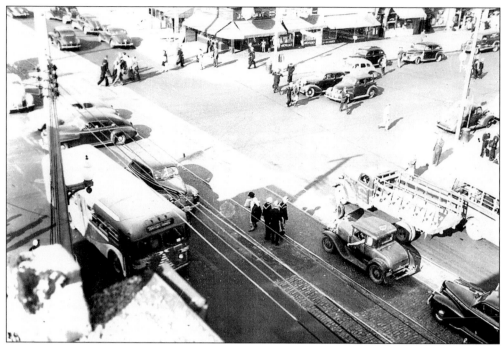

A motorist signals for a courteous left turn as pedestrians and vehicles vie with another in the crowded days of the 1940s. By 1940, the census reported 50,745 people living in Portsmouth. (Courtesy Portsmouth Public Library.)

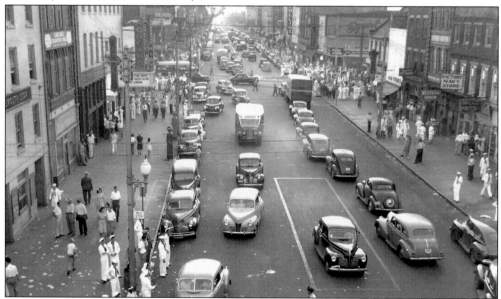

Police officer Buddy Broughton crosses High Street safely on these crowded 1940s streets. A sea of white uniforms graces High Street in this view looking west from Crawford. The small box is for cars waiting to load on the ferry to Berkley. Those going to Norfolk would travel down London Street and then enter a waiting line on Water Street. Taxis crowded the northwest corner of High and Water Streets at the far right of this photo in order to vie for pedestrians wanting a ride. (Courtesy Portsmouth Public Library.)

Five

THE POST-WAR ERA

In 1952, the city of Portsmouth celebrated its 200th birthday in a big way. A pageant directed by Bernard Levin involved hundreds of actors and assistants. Buildings were decorated with garlands, ladies wore sunbonnets, and gentlemen sported beards or paid a fine!

A major change came that bicentennial year, and it was one that had been in the making since a 1926 report showed vehicular traffic on the ferries was increasing at a rate of over 10,000 vehicles a month. Vernon A. Brooks, elected to two-year terms as mayor in 1928 and 1932, proposed a tunnel between the two cities as far back as 1928 to meet the demand for transportation between Portsmouth and Norfolk. However, the Virginia General Assembly did not establish the Elizabeth River Tunnel Commission until 1942 to investigate such a tunnel. What is today known as The Downtown Tunnel opened on May 23, 1952.

The ferries lasted only a while longer. On the evening of August 25, 1955, the last ferry trip was marked midstream by its passengers joining hands and singing "Auld Lang Syne." At 6:45 p.m., the last ferry docked in Portsmouth, and an end came to over 300 years of continuous ferry operation. Besides losing the pleasant ride across the river, Portsmouth citizens lost a number of businesses that no longer had the pedestrian traffic they needed.

These events could not be reported in The Portsmouth Star, for Portsmouth's independent newspaper had been sold to Norfolk Newspapers. The Portsmouth Star's final edition on April 3, 1955 noted the economic realities that have since forced many local newspapers in other cities to close.

An exodus of people from the downtown area was also taking place as part of a national trend of movement to the suburbs. Many businesses and other institutions followed. One such institution was Gomley Chesed Synagogue, which moved in 1955 from 519 County Street, where it had been since 1901. The congregation had originally been on High Street west of Green when founded in 1893.

More bad news was to come in 1955 as the Seaboard Air Line Railway announced in September that it was moving its headquarters from Portsmouth to Richmond. The railroad did soften the blow by giving its 1894 passenger station and office building, located at Number One High Street, to the city, and that building became the city's municipal building in 1958. A less visible change to city government came in 1956 when the city charter was changed to allow city council members to be elected at large instead of by wards.

To make way for parking and for new development in the mid-1950s, the city demolished a number of old buildings, many of them with historical significance. Concern over this led to the creation of the Portsmouth Historical Association on April 10, 1956. The Historical Association's efforts to promote pride in the city's heritage were helped by the great interest in the celebration of Jamestown's 350th anniversary in 1957, an interest heightened because nearby Port Norfolk's Curtis-Dunn Marine Shipyard built the full-scale replicas of the three ships that brought the first English colonists to Virginia. Port Norfolk was annexed in 1968.

The city got its first television station when WAVY-TV, Channel 10, began broadcasting in September 1957. The following year, Frederick Military Academy opened its doors, and lines of young gray-clad cadets soon graced Portsmouth parades.

Midcity Shopping Center opened at the intersection of Airline and Frederick Boulevards. It offered national stores such as J.C. Penney's, in addition to local ones such as Smith and Welton, a major retailer descended in part from Frank Welton's early store on High Street.

Downtown, stores were plentiful and full of fine goods that drew people to Portsmouth. The Famous, built on the site of the Hotel Monroe after its 1957 fire and owned by Zelma and Bernard Rivin, brought women to

Portsmouth from North Carolina as well as from nearby cities. The third generation of Rapoports was learning the craft of selling fine men's clothes at the Quality Shop with father Herman and grandfather Morris, who founded the shop in 1917. Glaziers, Fantone's and Sears' Betty and Bob, and Leggett's were among those that accompanied such landmarks as W.T. Grant's and W.F. Woolworth's department stores.

Economic prosperity had increased in no small part because Navy Yard employment had remained above 9,000 after World War II and increased during the Korean War to 16,100 by July of 1952. During this 1950–1952 period, the shipyard built two new ships and worked on over 1,250 naval vessels. Drydock Number Eight at the Navy Yard was enlarged in 1955 to accommodate the largest ships in existence. As the decade continued, employment dropped progressively, reaching 12,600 by 1956. The setting of a ceiling of 11,000 workers at the shipyard in 1959 was troublesome, but the Navy Yard started preparing to work on nuclear submarines.

As the 1950s came to a close, the Naval Hospital was completing work on a new building that would make new specialties available to serve the Navy, and the government was completing demolition of old homes on Crawford Street so a modern Federal Building could be erected. Many citizens wanted a more modern look for their city, and the coming decade would see many changes in the old city.

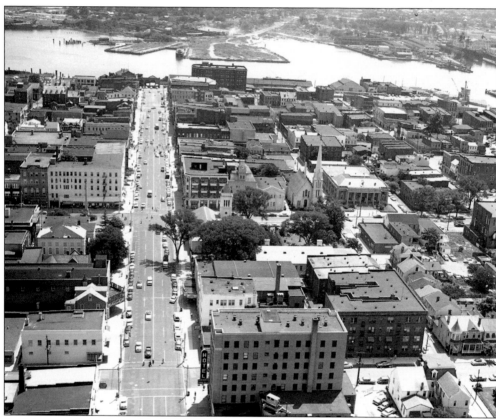

In this scene from the early 1950s, the Hotel Portsmouth (later the Dinwiddie Hotel) in the 500 block of High Street is at the lower right. In the 400 Block just beyond the hotel are the Commodore Theater and Trinity Episcopal Church. Directly across from the Commodore is the State Theater, and the large white building at the intersection of High and Court Streets is the Monroe Hotel. A block further right (south) along Court Street, First Presbyterian Church and the Post Office Building are on opposite sides of the eastern intersection of Court and KIng Streets. At the foot of High Street is the ferry terminal, and to the right of the terminal is the Seaboard Air Line Railway's headquarters building and train station. (Courtesy Portsmouth Public Library.)

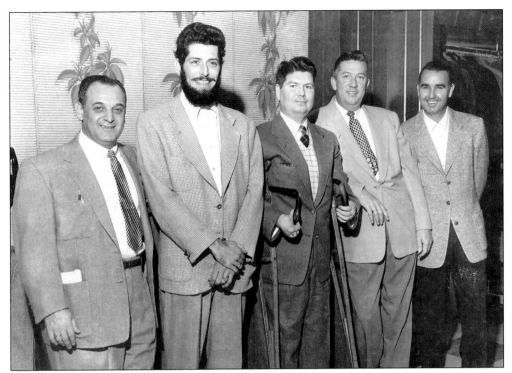

From left to right are businessmen Jake Barney and Les Fry (bearded), Red Cross Executive Director Frank Kirby, City Manager H.M. Myers, and golf pro Harry Kelly. (Courtesy Portsmouth Public Library.)

A well-dressed woman waits her turn to buy a ferry ticket in the early 1950s when a lady would not have ventured out without her gloves and hat. A tunnel to Norfolk opened on May 23, 1952, and the ferries ceased operation three years later. (Courtesy Portsmouth Naval Shipyard Museum.)

85

A little boy observes the changing scene at the foot of High Street as a bus turns right on Water Street. The ferries continued to connect Norfolk and Portsmouth as they had since 1636. Though modern bus service connected the ferries to outlying districts of the two cities, the days of ferry travel were numbered. (Courtesy Mike Williams Estate.)

Just to the south of the ferry terminal was the headquarters of the Seaboard Air Line Railroad. A bridge connected that building to the *Portsmouth Star*'s offices at the southwest corner of Water and High Streets. (Courtesy Portsmouth Public Library.)

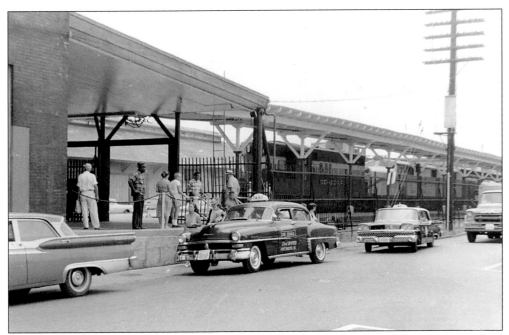

The train station behind the Seaboard Building looked much the same in later years as it had during the 1940s. Increased rail, port, and Navy Yard activity brought more people to the city, and by 1950 Portsmouth had a population of 80,039. (Courtesy Portsmouth Public Library.)

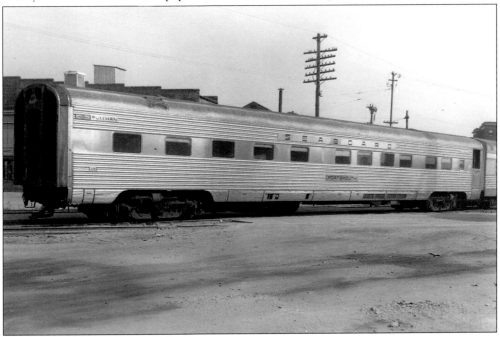

The name "Seaboard" appeared on the Seaboard Air Line Railroad's cars and the name "Portsmouth" could be read just below the windows. Trains such as the famed Orange Blossom Special carried such cars along the Eastern Seaboard states. Headquartered in Portsmouth, the railway spread Portsmouth's name far and wide. (Courtesy Portsmouth Naval Shipyard Museum.)

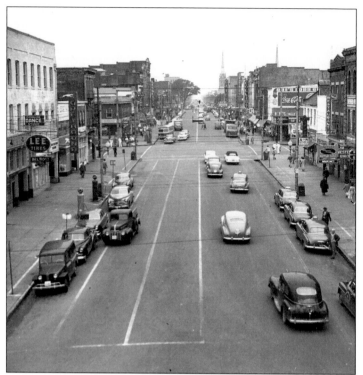

High Street was bustling in 1952. The gas station on High Street near Crawford at left seems out of place by modern standards, and it is still a wonder that large buses made the turn into the Greyhound bus station just beyond it. (Courtesy Mike Williams Estate.)

Just a block west of the ferry terminal, a fashionably dressed teen looks in the window of Kresge's Department store as adults wait for the bus in front of the Morris Company at 206 High Street. (Courtesy Portsmouth Naval Shipyard Museum.)

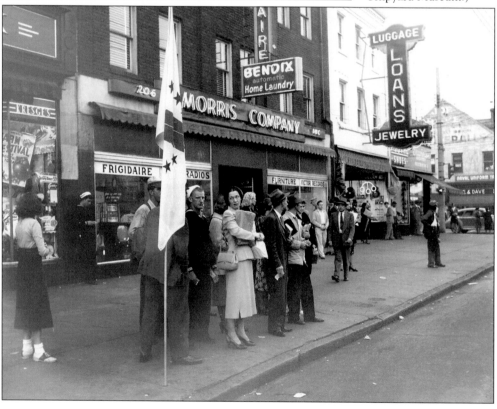

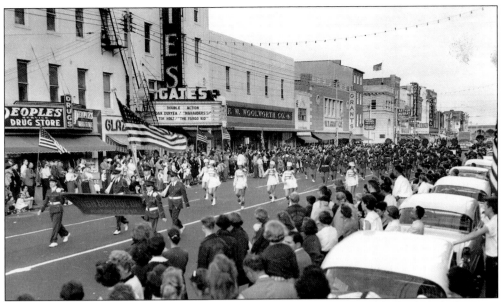

This Mike Williams photograph shows the northern side of the 300 block of High Street in 1956 as a high school band marches past. Peoples Drug Store, Glazier's Department Store, and the Gates Theater were in the first floor of the Monroe Hotel. F.W. Woolworth Co., Chapman's jewelry store, W.T. Grant Co., and Fantone's store were beyond. Across Middle Street, American National Bank is the large structure with the American flag flying on top. (Courtesy Portsmouth Public Library.)

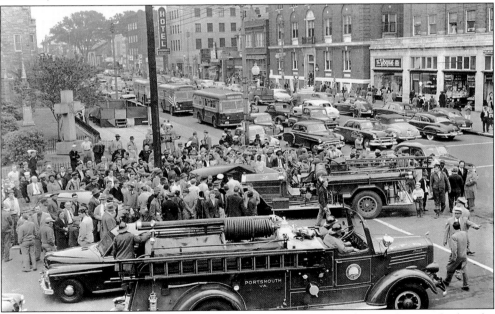

Traffic was heavy in this era and mishaps often occurred. In 1953, this accident resulted in the death of a fireman at the intersection of Washington and High Streets. At the left, the cross stands by St. Paul's Roman Catholic Church. Across the street, the Professional Building, the YMCA, and the Dinwiddie Hotel are visible on the south side of the 400 block of High Street. (Courtesy Portsmouth Public Library.)

On the southeast corner of High and Effingham Streets, the department store's name changed from Bloomberg's to Bradshaw Diehl during the 1950s. People still dressed up to go shopping, as seen in this October 1958 photograph. (Courtesy Estate of Mike Williams.)

The Grant Nozzle was cited as a potent weapon in the Battle of Britain, but it also saved many lives throughout the world with its ability to deliver a continuous stream of water at high pressure to fight fires. Jordan Winslow Grant was recognized for this invention by a monument erected in 1946 beside the 1945 fire station at 361 Effingham Street. Shown here are Fire Chief W.B. Sykes, Sherwood Brockwell (fire marshal for North Carolina), S. Deal Blanchard (president of the Portsmouth Junior Chamber of Commerce), and David M. Grant, nephew of Mr. Grant. (Courtesy Portsmouth Public Library.)

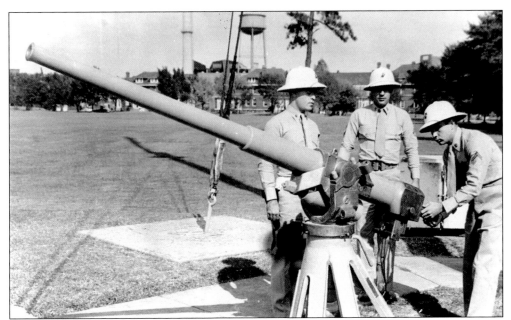

The coming of peace did not still all guns, for the "Nine O'clock Gun" was still fired at the Navy Yard. Naval tradition going back to 1847 had a gun fired at 9 p.m. to signal "tattoo," a preliminary signal before what we call "taps" today. The shipyard shifted from using the artillery on a ship to using a gun in Trophy Park in 1941 and the firing of the gun has been a loud signal for generations of Portsmouth children that it was time to cease playing and come home. (Courtesy Portsmouth Public Library.)

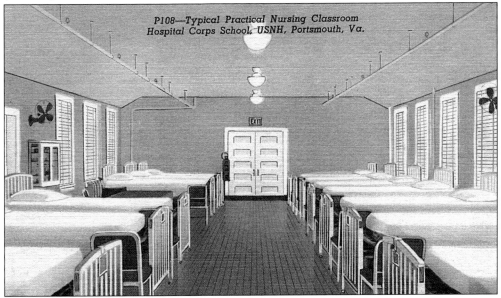

The Naval Hospital in the 1940s and 1950s featured electric fans to provide modern cooling, but the main comfort still came from the cool breezes along the Elizabeth River. The breezes gave rise to windmills being built there by the Tucker family, who lived on this land from 1718 until the 1790s. The point of land became known as "Windmill Point," but is now called "Hospital Point." (Courtesy Al Cutchin.)

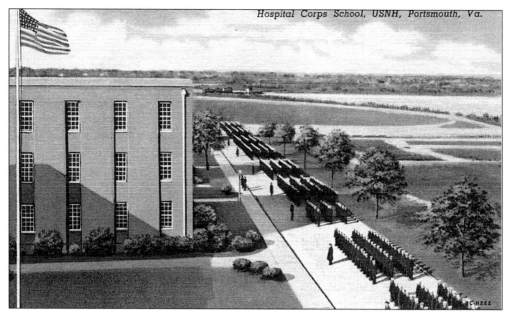

The Hospital Corps School operates as a separate command from the Naval Hospital. It continues to be a major training center for medical corps personnel. The school, the hospital, and much of the nearby Park View neighborhood are on land which belonged to Thomas Willoughby. (Courtesy Al Cutchin.)

In 1952, Portsmouth celebrated its 200th anniversary. As part of the celebration, women dressed in sunbonnets and men sported beards or paid small fines. For this picture, employees of the Seaboard Air Line Railroad posed in their bicentennial best in front of the Seaboard Building at the foot of High Street. (Courtesy Portsmouth Public Library.)

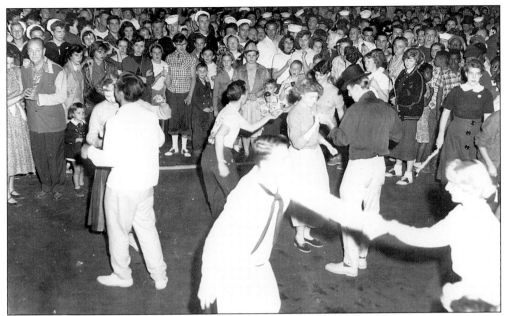

Though there were speeches and historic events for the 1952 Portsmouth Bicentennial, there were also parades and evening events like this one. Fireworks and dancing in the streets were highlights of the celebration. (Courtesy Portsmouth Public Library.)

Modern firefighting equipment replaced older gear. Seen at the Naval Shipyard in 1952, John Hunt, a surviving member of Chamber's Fire Company Number Two, posed by a decorative vehicle of an earlier time. Portsmouth's first firefighting unit, The Resolution Fire Company, was organized in 1830. (Courtesy Portsmouth Public Library.)

Queen for a Day was one of the more popular daytime television shows, and the city got national exposure when an episode was broadcast from the Elm Street arsenal in the 1950s. (Courtesy Portsmouth Public Library.)

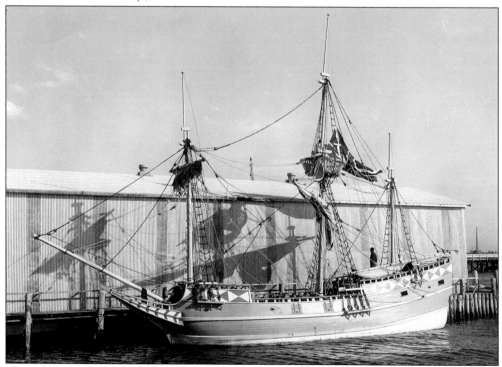

When Jamestown celebrated the 350th anniversary of its founding in 1957, Portsmouth residents took particular pride that the replicas of the three ships that brought the colonists were built in their city. The Curtis-Dunn Marine Shipyard, located in the West Norfolk portion of the city, constructed the vessels. (Courtesy Portsmouth Naval Shipyard Museum.)

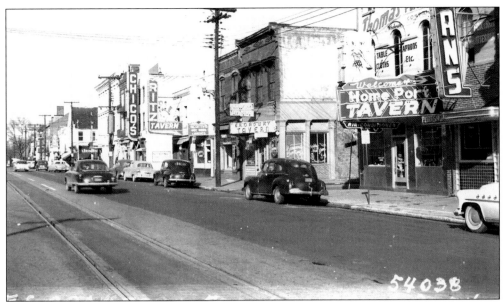

Portsmouth's Crawford Street had quite a reputation. The bars and tattoo parlors presented as unwholesome an image as did the ones on East Main Street in nearby Norfolk. This picture shows the east side of the 500 and 600 Blocks of Crawford Street in 1954. (Photo by J.A. Murdaugh, Courtesy Portsmouth Public Library.)

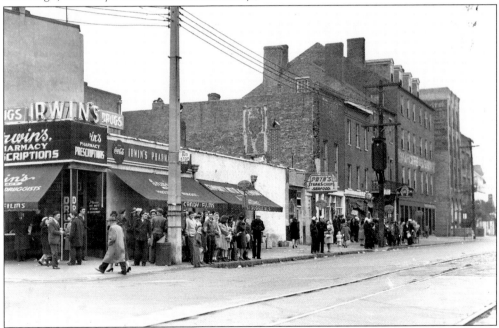

The area near the northwest corner of High and Crawford Streets in the 1950s looked much as it did in this 1947 photograph. The large building with dormer windows was the Crawford House Hotel, which was Portsmouth's first five-story building. Erected in 1835 by J.W. Collins, it was the second site of the Sisters of Mercy's Hospital in 1861. Presidents Van Buren, Tyler, and Fillmore were entertained here. All of these buildings were torn down in later years. (Courtesy Portsmouth Public Library.)

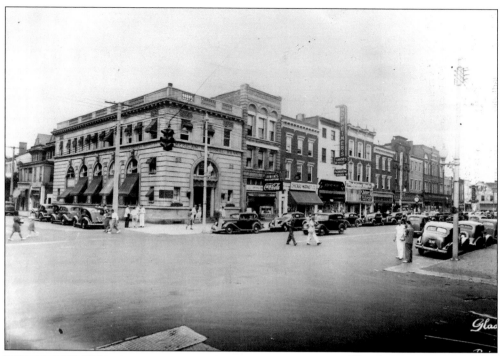

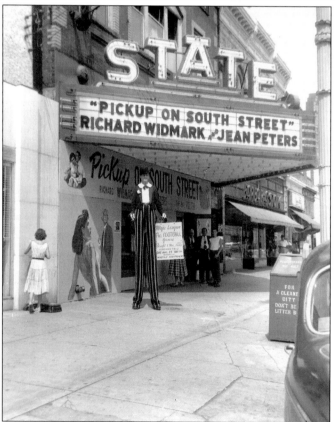

The American National Bank was at the northeast corner of High and Middle Streets. Above the front door and above each first-floor window was a carved lion's head. One of these stone figures survives at the top of the arch in Lafayette Park, located at the southeast corner of Crawford and Glasgow Streets. (Courtesy Portsmouth Public Library.)

The State Theater, located just east of St. Paul's Roman Catholic Church in the 500 block of High Street, used sultry advertising and a stilt walker to drum up business for this movie during the 1950s. (Courtesy Portsmouth Public Library.)

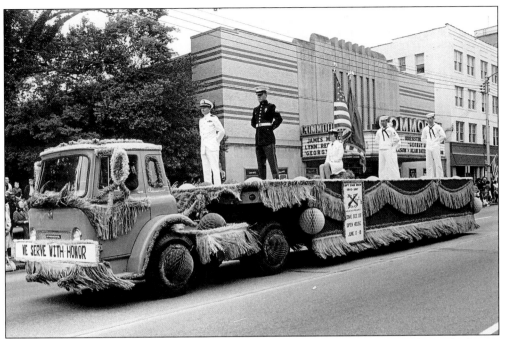

A float passes by the Commodore Theater, a magnificent Art Deco building which was constructed in 1945. This movie palace was part of the Wilder Theater chain of Portsmouth-born Bunkie Wilder. Restored in 1988, its interior murals, state-of-the-art sound system, and dining services make it a popular destination today. The name of the theater is taken from its proximity to the tomb of Commodore James Barron at left in the churchyard of Trinity Episcopal. (Courtesy Portsmouth Public Library.)

Snow falls at Woodrow Wilson High School. Built in 1917–1918, its spacious rooms and nearby gym (seen just to the right) reflected the state of the art at that time. This building became Harry A. Hunt Junior High School after a new Wilson High was built in the 1960s. (Courtesy Portsmouth Public Library.)

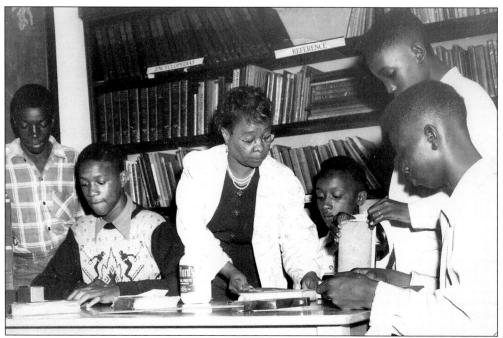

Miss Ora Churchill works with children at the school library. Teaching in the public schools from 1915 to 1966, she lived to see schools integrated before she retired. She was a civic leader and historian who did much to preserve not only the African-American experience in Portsmouth but also the heritage we all share. (Courtesy Portsmouth Public Library.)

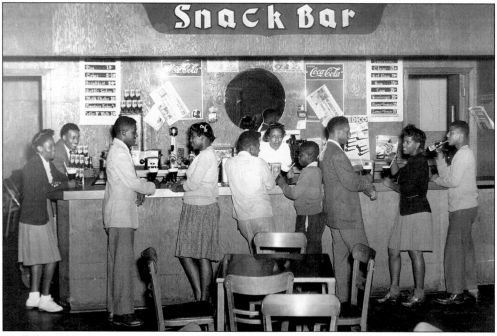

Well-dressed youngsters enjoy the social life at the Chestnut Street YMCA in the 1950s. Schools as well as social activities were segregated in those days. (Courtesy Portsmouth Public Library.)

Christmas brought shoppers together downtown at department stores such as Bloomberg's. This picture of the southeastern corner of High and Effingham Streets in the 1950s shows the gigantic animated Santa which was quite a novelty at that time. (Courtesy Portsmouth Public Library.)

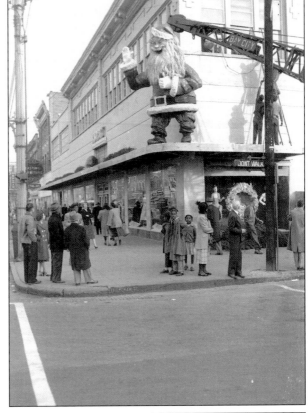

The White Rabbit, located at Alexander's Corner where Airline Boulevard met Portsmouth Boulevard, was a popular restaurant. Along with the Circle and Rodman's, it served the population that was increasingly moving away from the downtown area. (Courtesy Portsmouth Naval Shipyard Museum.)

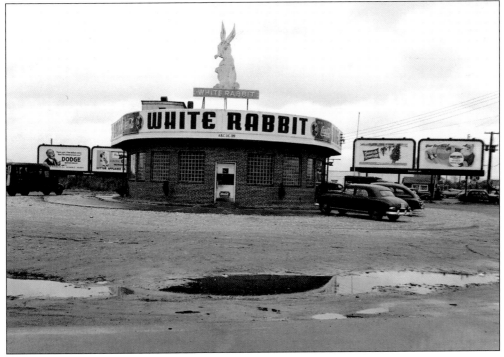

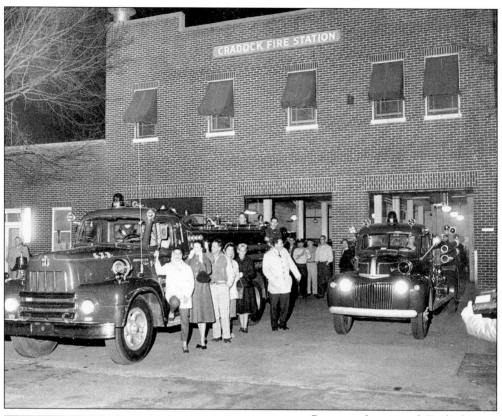

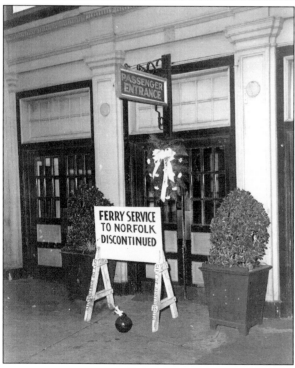

Portsmouth annexed Cradock from Norfolk County. Shown here on the night of December 31, 1959, people await the change. Promptly at midnight, the Norfolk County fire engines left and those of Portsmouth moved into the fire station. (Courtesy Estate of Mike Williams.)

The closing of the ferries on August 25, 1955 ended over 300 years of service to and from Portsmouth's sister city. The funerary wreath beside the sign was an accurate omen of the fate that would befall many shops that depended on the foot traffic, which the ferries generated. (Courtesy Portsmouth Public Library.)

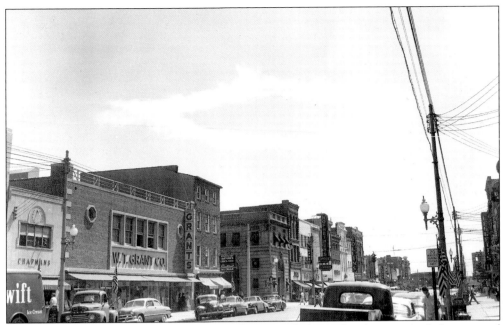

The ominous circular cloud over Portsmouth was made by a plane's vapor trail. It suggested the mushroom-shaped cloud of a nuclear explosion and made a Civil Defense drill seem more realistic during those Cold War days of the 1950s. (Courtesy Portsmouth Public Library.)

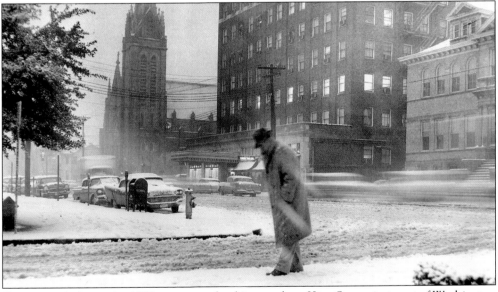

On a winter's day in the 1950s, a man makes his way along King Street, just west of Washington Street. Behind him is the building that was Portsmouth High School. After Woodrow Wilson High was completed in 1918 it served as Briggs Elementary School. Next to it, the 1929 Professional Building seems warm and safe though its lovely blue and white tile ornamentation near the roof is obscured by the snow. Across High Street, the cathedral-style architecture of St. Paul's Roman Catholic Church is seen. Its stone carvings of Christ in the Garden of Gethsemane and of Saint Paul are not shown, but the building is worth the trip to Portsmouth to admire such features! (Courtesy Portsmouth Public Library.)

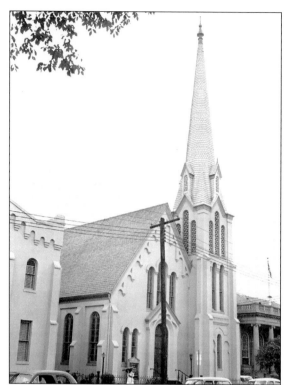

The origins of First Presbyterian Church date to May of 1821, and the congregation's first place of worship was at the northwest corner of Middle and London Streets. After fires destroyed buildings at the site in 1872 and 1877, the church moved to the northeast corner of Court and King Streets. Some of the English stained-glass windows from the earlier buildings are contained in the current structure, which was dedicated on September 26, 1877. (Courtesy *Virginian-Pilot and Ledger-Star*.)

This image of downtown Portsmouth with flags flying and shoppers strolling is the way many people recall the post-war era. Showing the 300 Block of High Street looking northwest from Middle Street, this photograph seems to capture the slower pace of life and the patriotism of those bygone days. (Courtesy Portsmouth Public Library.)

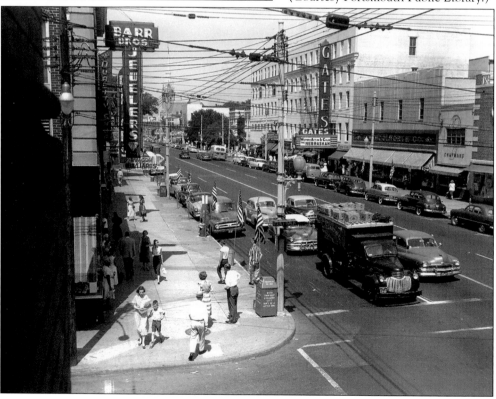

Six

THE MODERN ERA

On January 1, 1960, Portsmouth became Virginia's third-largest city. After annexing Cradock, Simonsdale, Elizabeth Manor and several other areas of Norfolk County, Portsmouth covered 18.8 square miles and included 114,775 residents. A $15 million Naval Hospital building was dedicated on April 22, and on April 29 a $3.5 million Federal Building opened with spaces for the post office, Fifth Coast Guard District, and other federal offices. Lastly, the Portsmouth Redevelopment and Housing Authority in 1960 began clearing 34 acres of property in Lincolnsville for redevelopment. This was followed in 1973 with the Mount Hernon Redevelopment Project, the largest such project undertaken in Virginia.

The Civil Rights Movement came to Portsmouth in 1960. Efforts for African Americans to desegregate the new Midcity Shopping Center resulted in a confrontation that was reported nationally in the February 29, 1960 issue of Life magazine. Subsequent sit-ins and demonstrations, however, brought peaceful integration to every aspect of life in the city.

On September 12, 1961, Frederick College, destined to become part of Tidewater Community College in 1987, opened as a four-year educational institution. Other signs of a new era came in 1962 as the Navy Yard began working on nuclear submarines and as the Midtown tunnel to Norfolk opened on September 6th. Portsmouth's first museum, the Naval Shipyard Museum, opened in January of 1963 at Number Two High Street. Also in 1963, the Public Library opened its main branch in the former post office building at 601 Court Street. That year, the city officially recognized Olde Towne as an historic area.

Two major economic initiatives soon followed. Modern commercial buildings began appearing on Crawford Street as the 1965 Colonel Crawford Commons Plan was implemented. Containerized cargo ships increasingly came to Pinner's Point following the September 20, 1967 opening of the Portsmouth Marine Terminal, a facility designed to handle the new ships and was the envy of other East Coast ports.

Portsmouth also honored its past that year. The Portsmouth Lightship Museum opened in 1967, and the lightship was later listed as a National Historic Landmark. The Olde Towne Historic District was established on October 24, 1967, and a Commission of Architectural Review was created the following year. In 1968 Olde Towne and Park View became Virginia's first two conservation projects, a status that allowed low-cost loans and other services from Portsmouth Redevelopment and Housing Authority to help property owners save their historic homes.

On January 1, 1968, Portsmouth extended its boundaries by annexing Craney Island, part of Churchland, West Norfolk, and Western Branch from Norfolk County. This eighth and last expansion stretched the city to its current size of 30 square miles in 1968 and helped increase Portsmouth's population to 110,963 by the 1970 census. The elections of Raymond Turner and Dr. James W. Holley III as the city's first two African-American members of the city council were landmark events in 1968.

There were major changes during 1969 as well. Along the eastern waterfront, construction began on a seawall that featured a wide walkway for pedestrians.

In 1976 Portsmouth was recognized as an All American City by the National League of Municipalities, and the city charter was amended to allow the mayor to be elected directly by the citizens. Cradock and Truxtun became officially designated Historic Districts that year, and, thanks largely to the leadership of J. Herbert Simpson, The Virginia Sports Hall of Fame opened in the former Norfolk County Clerk's Office. In 1980, Trish Pfeifer helped create the Children's Museum, an interactive hands-on learning center, in the basement of the public library.

Despite signs of progress as the new municipal complex in the 800 block of Crawford Street opened in 1980, concern grew as that year's census showed the population had declined to 104,577. To help improve the city,

in 1982 a Department of Economic Development was established. In 1983 work started on North Harbor, a project by the foot of North Street that added docks for boaters as well as a ferry landing near PortSide, a public entertainment area featuring vendors under a colorful tent. Promotion of tourism was a particular focus of the efforts of George L. Hanbury II, city manager from 1983 to 1991. He also developed the Western Freeway in Churchland and the Port Centre industrial park near the Navy Yard.

Meanwhile, Portsmouth was preserving its heritage. The city established the Port Norfolk Historic District on April 26, 1983, and the Park View Historic District on April 1, 1984. The 1848 Court House was saved when the 1984 restoration gave it new life with a second-floor art gallery above the Children's Museum of Virginia at ground level. The children's museum moved to its own building at 221 High Street in 1994.

"Vision 2005," adopted in 1993, provided a strategic plan for future growth, much of which was the basis for changes brought by Ronald W. Massie, city manager from 1995 to 2001. High Street Landing, with a ferry and small boat docks, was created at the eastern end of High Street in 1997, and in 2001 the Portsmouth Renaissance Hotel, the Ocean Marine boat-repair facility, and the Ntelos Pavilion amphitheater opened along the downtown waterfront. Portsmouth's skyline has also been changed by the April 30, 1999 opening of the five-story Charette Health Care Center, the third major building in Portsmouth's naval hospital complex. These developments have brought more visitors and more shops to Portsmouth's quaint downtown.

Strolling its shaded streets, shopping for antiques and collectibles, or dining at its interesting restaurants, increasing numbers of tourists are discovering the joys of this surprising city. After so many colorful and sometimes turbulent years, Portsmouth continues to preserve its past while embracing a promising future that will further fulfill the vision of William Crawford 250 years ago.

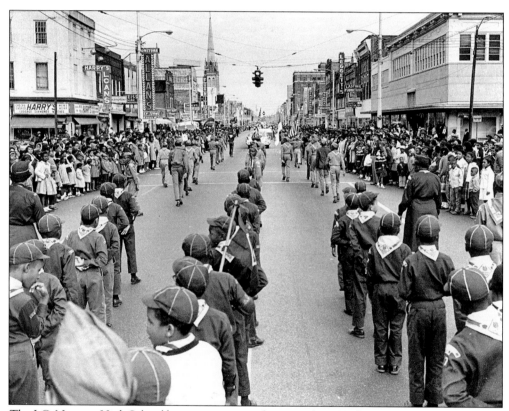

The I.C. Norcom High School homecoming parade passes along High Street near its intersection with Effingham Street on October 25, 1962. Though not shown here, the school's "Marching Greyhounds" band is fabled for its musical abilities and showmanship. (Courtesy Portsmouth Public Library.)

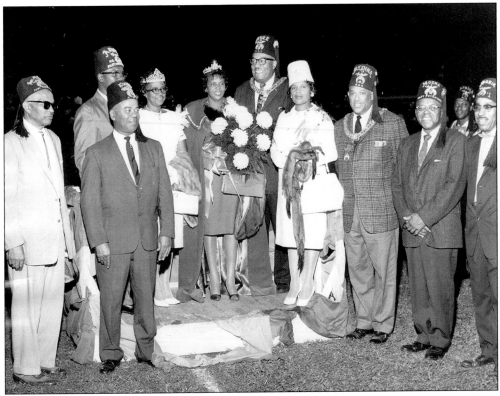

Carrie Brooks, Fish Bowl Queen 1961 (center), and the 1961 director of the Fish Bowl Classic, Noble Milton W. Keeling (far right), are shown in this photograph. The parade, festivities, and football game that benefits charity are activities which bring people from across the mid-Atlantic states to the annual Fish Bowl celebration, which Portsmouth's Arabia Temple Number Twelve produces each fall. (Courtesy Portsmouth Public Library.)

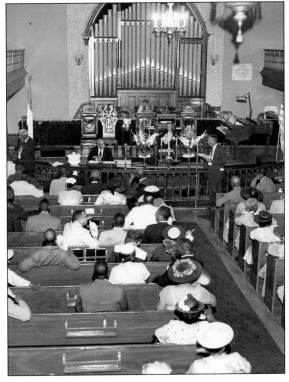

Religious life has been important throughout Portsmouth's history and visitors often comment on the concentration of churches in the downtown area. This worship service took place inside Emmanuel African Methodist Episcopal Church at 637 North Street in the 1960s. (Courtesy *Virginian-Pilot and Ledger-Star*.)

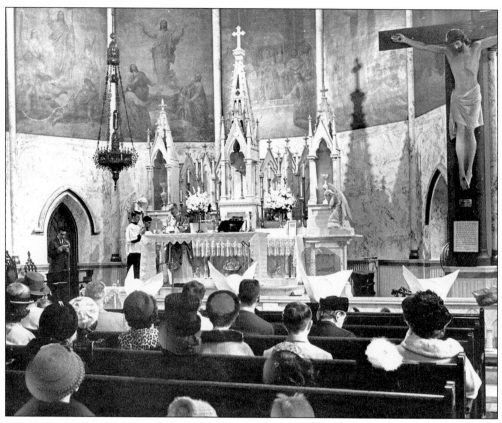

Worshippers are shown at St Paul's Roman Catholic Church, located at the northeast corner of High and Washington Streets. Notice that the nuns had the first row reserved for them and that they still wore distinctive habits. (Courtesy *Virginian-Pilot* and *Ledger-Star*.)

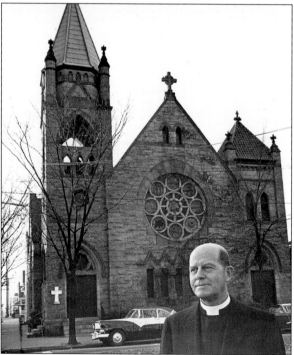

Rev. Roderick H. Jackson, rector from 1940 to 1967, stands in front of St. John's Episcopal Church in this 1961 photograph. The church's rose window and cathedral-style architecture grace the northwest corner of London and Washington Streets. The congregation was organized following a split among parishioners at nearby Trinity Church in 1848. The current building was opened on September 24, 1898. (Courtesy *Virginian-Pilot* and *Ledger-Star*.)

In September of 1962, the final records of the Norfolk County Clerk's Office were transferred from Portsmouth to the new municipal center at Great Bridge, a portion of Norfolk County which became part of the newly created city of Chesapeake on January 1, 1963. The administration of Norfolk County had been centered in Portsmouth since 1803. (Courtesy Estate of Mike Williams.)

Photographer Mike Williams captured this scene of flooding at the downtown tunnel in 1962 during the Ash Wednesday Storm. Installation of a modern seawall and new pumping equipment would prevent such a scene shortly, but here the water finds its way near where Gander Creek—sometimes called Crab Creek—once flowed. The constant drone of traffic taking the tunnel and the lack of code enforcement in Southside eventually resulted in the destruction of many once fine homes such as those shown in this picture. (Courtesy Portsmouth Public Library.)

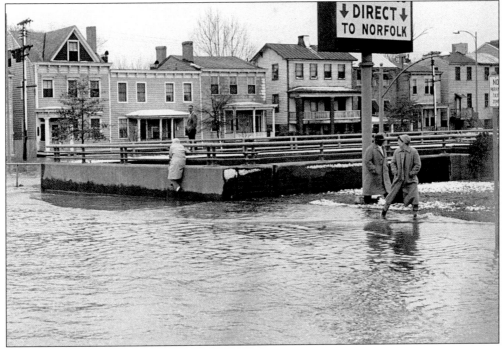

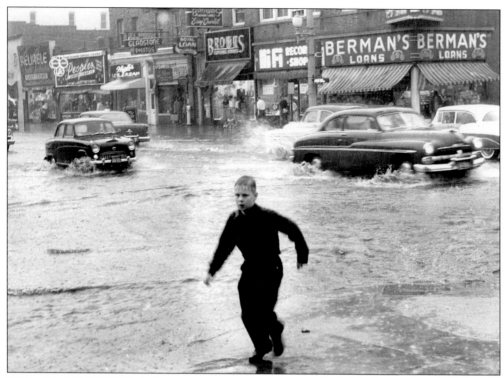

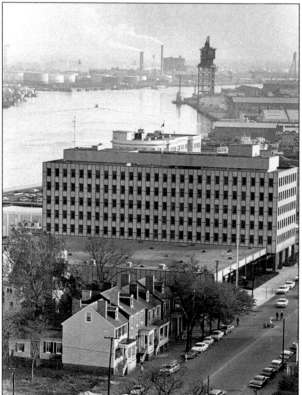

Probably during the same storm in 1962, a young boy navigates the intersection of High and Washington Streets. The 600 Block of High Street now features many antiques and collectibles stores which draw shoppers from throughout the region. (Courtesy Portsmouth Public Library.)

This photograph from November 20, 1964 shows Benthall-Brooks Row's restored houses standing in sharp contrast to the Federal Building which opened at the southeast corner of Crawford and London Streets on April 29, 1961. In the distance, the shipyard's distinctive hammerhead crane is a Navy Yard landmark which shows how close the shipyard is to downtown and Olde Towne Portsmouth. (Walker photo, Courtesy *Virginian-Pilot and Ledger-Star*.)

Mrs. W.B. Spong Sr. (known affectionately as "Miss Emily"), second president of the Portsmouth Historical Association, and P. Stockton Fleming, chairman of the Portsmouth Redevelopment and Housing Authority, are shown admiring the historic marker which still exists at the northwest corner of High and Crawford Streets. By leading efforts to recognize the city's past and to save its historic buildings, she played a crucial role in preserving the city's distinctive heritage. (Courtesy *Virginian-Pilot and Ledger-Star*.)

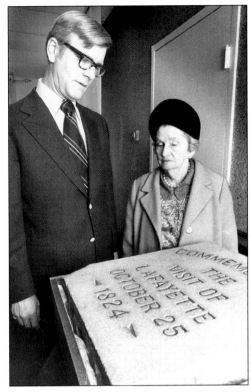

In 1963, Portsmouth officially recognized Olde Towne as an historic area. Two years later, the Grice-Neely House at 202 North Street was restored by a corporation consisting of Bill Spong Jr., Robert Reed, Henry Mackenzie, Jimmy Parish, and John Paul C. Hanbury. This was the first historic restoration in Olde Towne, and the subsequent revitalization of the quaint neighborhood has made it a growing tourist attraction. (Courtesy *Virginian-Pilot and Ledger-Star*.)

This basement-style home was given by Miss Evelyn Hill to the Portsmouth Historical Association in November of 1961. The Portsmouth Historical Association had been organized on April 10, 1956. (Courtesy *Virginian-Pilot* and *Ledger-Star*.)

Miss Evelyn Hill (left), Mrs. Berkeley M. Fontaine (middle), and Miss Elizabeth "Lizzie" Hill stand in the beautiful double parlors that were used for entertaining. Large mirrors make the room seem even larger and more stately. Louise Fontaine was a renowned history teacher at Woodrow Wilson High School and a stalwart of the early Portsmouth Historical Association. (Courtesy Portsmouth Public Library.)

In an upstairs bedroom of the Hill House during the 1960s, a display of women's 19th-century fashions is shown being prepared by Mrs. Robert B. (Louise) Albertson and Mrs. Leo P. (Elizabeth) Blair. The Hill House is one of the few museums in the United States in which everything from doilies to doiles is authentic to the family who lived in the house. (Courtesy Portsmouth Public Library.)

This photograph shows the 1960 Naval Hospital building in the background with the old 1830 building and its many additions in the foreground. With the opening of the new structure, the additions were taken down and the old building was remodeled to house the maternity ward. (Courtesy *Virginian-Pilot and Ledger-Star*.)

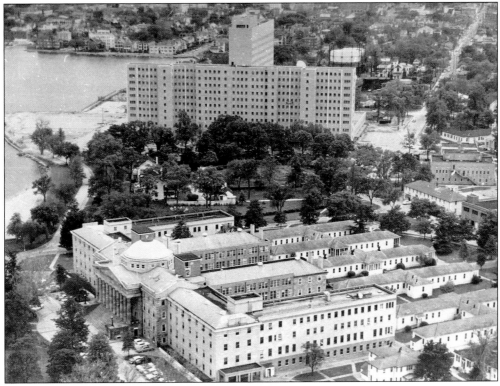

A reminder of the Cold War was the Polaris Missile erected at the eastern end of High Street. The missile stood in stark contrast to the Christmas decoration in this photograph from December of 1965. (Courtesy Estate of Mike Williams.)

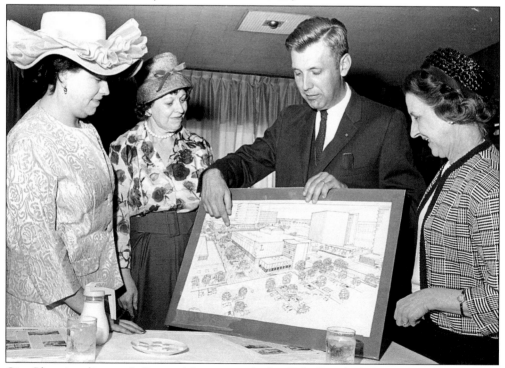

City Planning director J. Brewer Moore unveils the Col. Crawford Commons plan in 1965. Mrs. H.M. Prinz and Mrs. Frank Thompson are to his right and Mrs. John Davis is at his left. Implementation of the plan brought more modern high-rise buildings to the downtown area. (Courtesy *Virginian-Pilot* and *Ledger-Star*.)

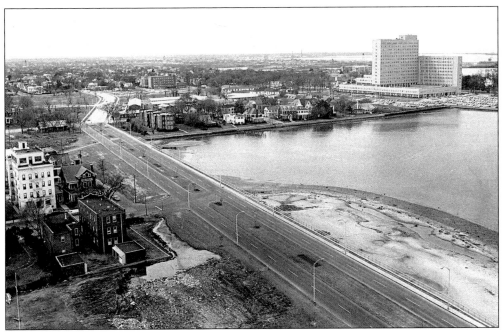

Crawford Parkway was built to help traffic flow and to provide protection from flooding by the Elizabeth River. The large white building at left was Parrish Memorial Hospital, but had been converted to apartments at the time of this March 1966 photograph. The Swimming Point neighborhood and the 1960 Naval Hospital are at the right. The inlet is known as Crawford Bay—named for Col. William Crawford, who founded the city in 1752. (Courtesy Estate of Mike Williams.)

The 1945 fire station at the southeast corner of Effingham and North Streets replaced the old Court Street fire headquarters. It was demolished in 2002. The 1960 Naval Hospital can be seen in the distance of this June 8, 1965 photograph. (Courtesy *Virginian-Pilot and Ledger-Star*.)

The old City Park Bridge used to carry cars, but it found a happier use by these folks in 1965. City Park today features a large recreation area, the Friendship Gardens, and a nine-hole public golf course. (Courtesy *Virginian-Pilot* and *Ledger-Star*.)

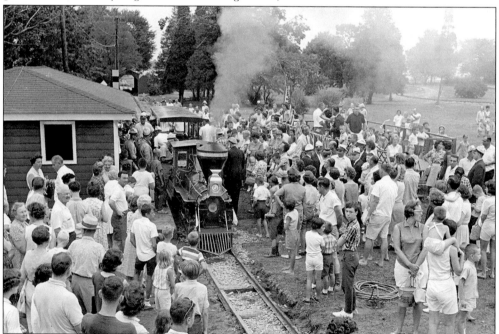

Pokey Smokey is a small railroad near the golf course at City Park. This steam engine ride has delighted youngsters since the 1960s. (Dick Bruske photo, courtesy *Virginian-Pilot and Ledger-Star*.)

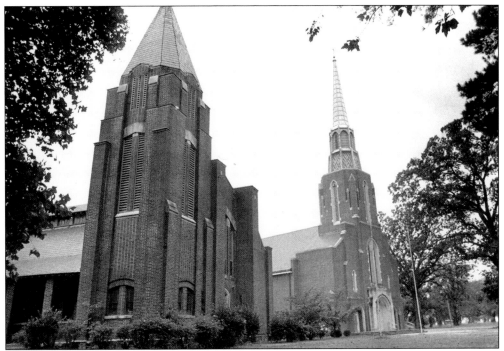

Churchland Baptist Church was founded in 1785, and many Baptist congregations in the region are descended from it. Originally called Shoulder's Hill Baptist Church, it moved to Sycamore Hill in Churchland in 1829 and took its present name in 1840. The 1910 and 1963 church buildings both show in this 1976 photograph. (Jim Bye photo, courtesy *Virginian-Pilot and Ledger-Star.*)

Developed to provide housing for Navy Yard workers in 1918, Truxton and Cradock became historic districts in 1976. Here Mrs. Rachel Harris and granddaughter Sheila Teartt tend to the yard on Manly Street in Truxton during 1981. (Courtesy *Virginian-Pilot and Ledger-Star.*)

The bell from the former Court Street Fire Department Headquarters was made an historic display at the 1945 fire station in 1987. At the dedication were Vice Mayor Gloria Webb, Mayor James W. Holley III, City Manager George Hanbury, Councilman Herbert Simpson, and Fire Chief Odell Benton. Dr. Holley had become Portsmouth's first African-American mayor in 1984, and he was succeeded in office by Ms. Webb, the city's first female mayor. Dr. Holley was returned to the office in 1996, and he is again mayor during the city's 250th anniversary in 2002. (Courtesy *Virginian-Pilot and Ledger-Star*.)

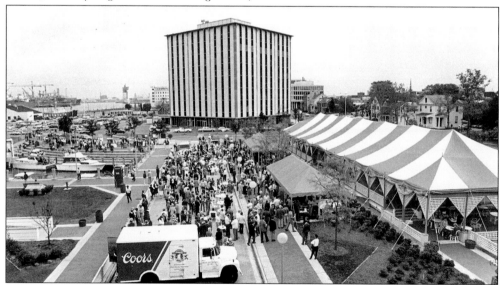

Portside featured small eateries and shops beneath a colorful blue and white tent along Crawford Street near a ferry dock, floating bandstand, and area for docking private boats. The tall structure just beyond it in this 1986 photograph was the Citizen's Trust Bank Building. (Courtesy *Virginian-Pilot and Ledger-Star*.)

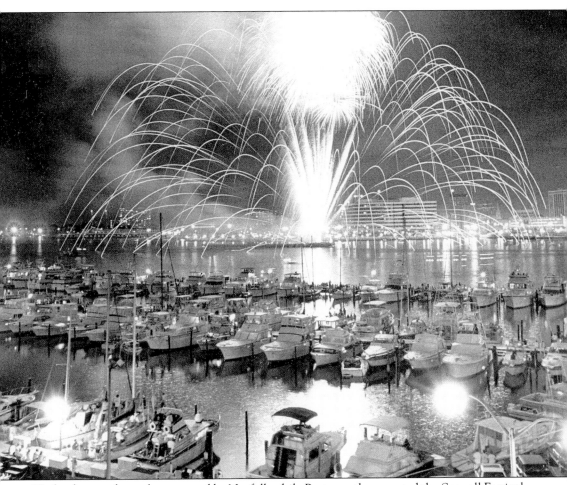

Harborfest was formerly sponsored by Norfolk while Portsmouth promoted the Seawall Festival, but now both cities present the waterfront festival during early June and have built it into one of the state's most highly rated events. Here, the many boats that now dock at Portsmouth are seen in the foreground while the Saturday night fireworks finale breaks forth in nearby Norfolk. Information on Portsmouth's many waterfront activities and festivals can be found at the websites of PortsEvents, a private non-profit corporation (http://www.portsevents.org), and of the city (http://www.portsva.com). Additional help can be obtained from Portsmouth's Convention and Visitor's Bureau. (Courtesy Estate of Mike Williams.)

Dr. Hugo Owens looks at artifacts with Ms. Elsie Askew during African American Heritage Day on February 2, 1992. He and Dr. James W. Holley III brought the 1960 lawsuit that integrated the public libraries, and in later years he became vice mayor of Chesapeake while Dr. Holley became mayor of Portsmouth. Today, our history provides a bond that unites all citizens and builds a firm foundation for the future. (Courtesy *Virginian-Pilot and Ledger-Star.*)

Portsmouth native William B. Spong Jr., a United States Senator and later president of Old Dominion University, walks with his wife, Virginia, and their children, Tommy and Martha, along the 300 block of North Street. Portsmouth's most famous silversmith, James Gaskins (born in 1761) had his shop in the lane behind the home at left. Beyond is the home of George W. Grice, who was elected mayor in 1856, 1859, and 1860. Portsmouth continues to be a good place for families to live and plan for a future that combines the best of the past and the present. (Courtesy *Virginian-Pilot and Ledger-Star.*)

Seven

WISH YOU WERE HERE

Scenes from the Portsmouth of bygone days have been preserved in the following postcards from the collection donated to the library by Arthur Lerman and Stanley Rosenberg. Accompanying them in this short chapter are some examples of how Portsmouth has preserved its historic past. Some links to former days are recounted in special events, while others are preserved in memorials and writings.

At Valley Forge with Washington and Lafayette during the American Revolution were two Portsmouth clergy. Jesse Nicholson, pastor of Monumental United Methodist Church in 1790 and 1792, is remembered by a plaque in his church. John Braidfoot, minister at Trinity Episcopal Church from 1773 to 1778, is buried in the churchyard of his former parish. The Reverend Mr. Braidfoot's encounter with a spectral horseman is an adventure that is among the authentic tales told by actors at the Olde Towne Civic League's "Ghost Walk," an event held once a year on the Friday before Halloween.

During the Revolution, the French located a convalescent hospital in the town "while van Stable's squadron was in Hampton Roads," as Moreau de St. Mery wrote in his 1794 journal. Though some may have discovered the town in other ways, at least two Frenchmen who remained in Portsmouth after the end of the American Revolution were to gain local prominence. A native of Luneville, France, and an aide to Lafayette, Bernard Magnien's later service as a colonel of the Portsmouth and Norfolk militia is still recalled by a marker to his memory in the churchyard at Trinity Episcopal. Antonio S. Bilisoly arrived with French Admiral de Grasse's fleet and was a leader in the city until his death in 1845.

Miss Mildred M. Holladay's 1936 History of Portsmouth saves the names of old families, and it also relates vanished customs. Announcements of engagements were never in the newspaper in early days, Miss Holladay reports, but were delivered by hand exactly one week ahead of the wedding. When a suitable time had passed after the nuptials and the stork had brought a little bundle of joy to the happy couple, there was special procedure for the new mother to receive congratulations. Two days after the baby's birth, she wrote, the new mother would don her daintiest house gown and set out cake and wine. Every lady in her social circle was expected to call upon her, and each was expected to partake of the refreshments and propose a suitable toast.

Miss Holladay's also preserves the history of African Americans in Portsmouth. She notes that slaves were sold in front of the court house that was on the northeast corner of High and Court Streets before 1842, and she records that "free negroes" had to register within two months of arriving in the town or pay a fine. She also records stories such as those of Billy Flora's heroism at the Battle of Great Bridge and of an African American named Aberdeen who gave distinguished shipboard service in the Revolution before becoming a wealthy shipowner.

Another early chronicler was John A. Foreman, whose 1911 recollections are filled with bits of local lore. He states that William Peters' shipyard at the northeast end of Court Street had been the first to launch a ship with its masts in place; that Tom Duval was an African American who "did all the rigging" at his loft just south of the ferry landing at the base of North Street; and that 50 sea captains lived in Portsmouth during the 1800s. Along with the books and material left to the public library by J. Cloyd Emmerson and other thoughtful people, many more of Portsmouth's interesting and historic records have been preserved.

Throughout the city are public memorials to remind even the most casual observer of Portsmouth's past. A 1989 plaque erected by Portsmouth Flag Associates in Lafayette Park lists Portsmouth men who received the Congressional Medal of Honor: Richard T. Shea Jr.(July 1953), Charles Veal (September 1864), Raymond H. Wilkins (November 1943), David D. Barrow (May 1889), Thomas Jordan (August 1864), Wendell C. Neville (April 1914), and James Carver (June 1880). Veal was a private in the 4th U.S. Colored Troops in the Civil

War, Shea was last seen going under heavy fire to bring back more of his wounded men in Korea, and Neville fought in Vera Cruz, Mexico. One can only pause to reflect on their brave service and to marvel that so many winners of this high honor came from a single city.

In war or in peace, a characteristic of Portsmouth has been the strong initiative of its citizens. The growth of a whole series of specialty shops in the 600 block of High Street owes its origin to the 1996 opening of Anderson-Wright Rooms and Gardens by two entrepreneurs with a vision, Bill Schlaht and Philip Weber. The restoration of the 600 block of London Street is due largely to the members of the Olde Towne Civic League's vision in saving a crucial corner home in that block. The restoration of the Winter Wonderland at Coleman's Nursery, following the December 31, 1982 fire that destroyed its animated figures and displays was due not only to the commitment of Floyd Twiford but also to the support of the many people in the community who raised funds to preserve the holiday tradition centered on the site.

Despite its rich heritage, Portsmouth has had to work hard to make its name better known. Because there was already a Portsmouth Navy Yard in New Hampshire and because the federal government used the name of the largest nearby city when naming its facilities, Portsmouth's famous shipyard has been known as the Norfolk Naval Shipyard. Therefore, its accomplishments have often been more closely associated with Norfolk rather than with Portsmouth. Slowly the word has been getting out, though, as people discover Portsmouth through the city's promotion of its waterfront activities, museums, and historic sites. Perhaps the images and words of this small volume will tempt even more people to discover or to rediscover the many charms of Portsmouth, Virginia.

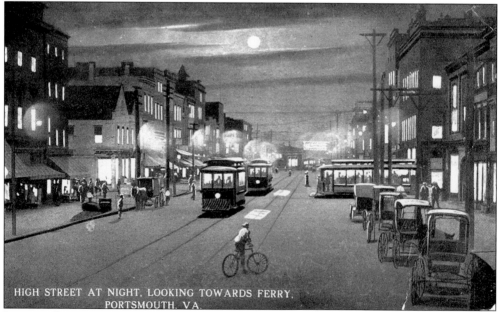

Imagine the excitement as streetcars brought shoppers downtown about a century ago. The Edison Electric Light and Power Company brought modern illumination to the city in 1889, and electric streetcars were introduced in 1897. (Courtesy of Portsmouth Public Library.)

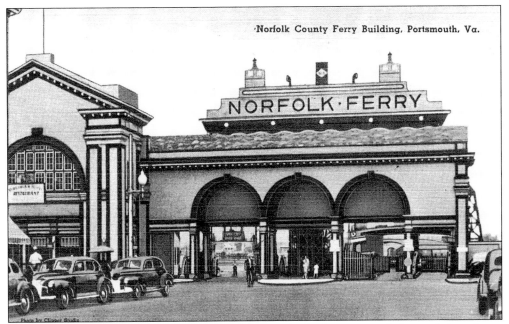

Norfolk County Ferry Building, Portsmouth, Va.

Connecting the downtowns of Norfolk and Portsmouth, the ferries provided a needed service as well as an enjoyable boat ride across the Elizabeth River. Today, this portion of High Street has been excavated to make a safe harbor for small boats and pedestrian ferries which once again provide the pleasures of waterborne travel between the two cities. (Courtesy of Portsmouth Public Library.)

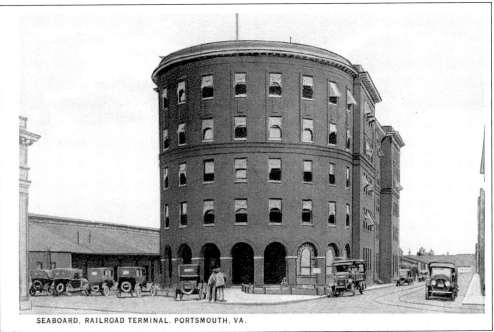

Just south of the ferry terminal was the Seaboard Air Line Railroad train station and headquarters. Known as the Seaboard Building, it still stands at Number One High Street. (Courtesy of Portsmouth Public Library.)

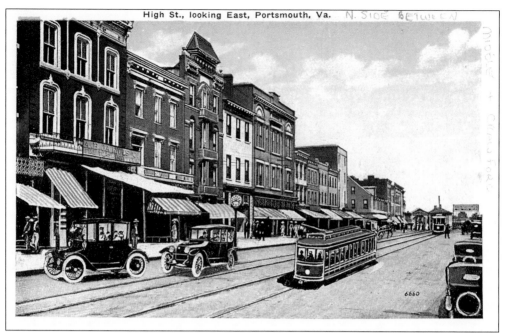

Looking northeast from Middle Street, this postcard shows the tall buildings along Portsmouth's busiest street. Although the buildings shown here have been demolished, similar buildings exist further west on High Street. (Courtesy of Portsmouth Public Library.)

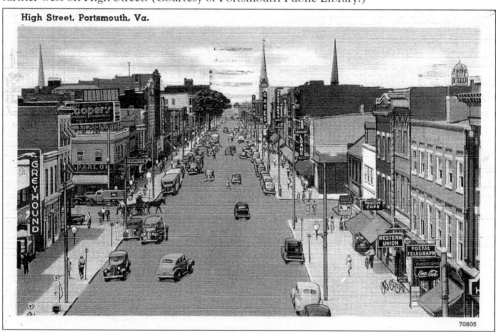

High Street, Portsmouth, Va.

A view looking west along High Street from just below Crawford Street shows the city was even busier in the several decades after the previous picture. The horse-drawn cart traveling north along Crawford Street seems strangely out of place amid so many automobiles. Church steeples from left to right are those of First Presbyterian, St. Paul's Roman Catholic, Monumental United Methodist, and Court Street Baptist. (Courtesy of Portsmouth Public Library.)

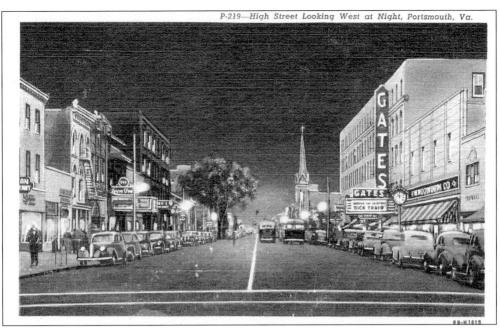

This postcard shows High Street as seen from Middle Street. The Gates Theater is at right and part of the Virginia Theater can be seen directly across from it at left. The Virginia was famous for showing cowboy movies in the 1950s and a local joke was that it had to close one day each week to dig the bullets out of the screen. (Courtesy of Portsmouth Public Library.)

8—COURT HOUSE AND MUNICIPAL BUILDING AND CONFEDERATE MONUMENT, PORTSMOUTH, VA.

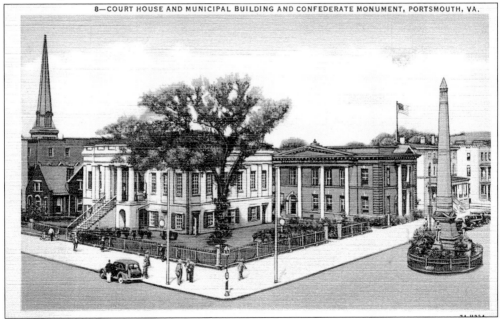

This postcard shows the scene looking northwest from the corner of High and Court Streets. Monumental United Methodist Church's steeple looms high above the Colony Theater. The Norfolk County Clerk's Office is to the left of the temple-like 1846 Court House. To the rear of the court house is the 1912 Municipal Building. In the middle of Court Street stands the Confederate Monument. (Courtesy of Portsmouth Public Library.)

123

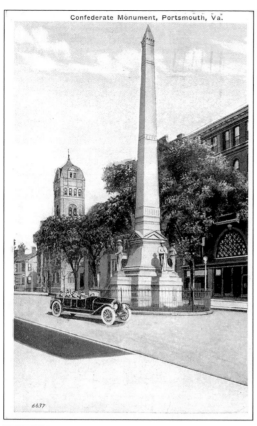

Confederate Monument, Portsmouth, Va.

6637

Portsmouth's Confederate Monument is one of the largest in the South. Facing west towards the automobile is a cavalryman, facing forward is an infantryman, and facing towards the hotel is an infantryman. Not shown is an artilleryman who faces west towards Court Street Baptist Church's distinctive tower. (Courtesy of Portsmouth Public Library.)

At left, children play along the tree-lined streets of Olde Towne much as they did in this view looking north along Court Street a century ago. (Courtesy of Portsmouth Public Library.)

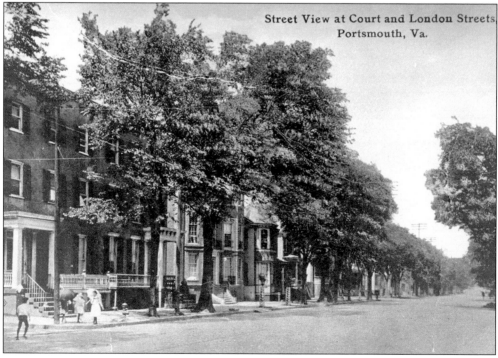

Street View at Court and London Streets, Portsmouth, Va.

Monumental United Methodist Church dates back to November 14, 1772, and it is the oldest continuous United Methodist Church south of the Potomac River. Francis Asbury, the famous Methodist minister, preached to its members. The congregation has worshiped at the southwest corner of Queen and Dinwiddie Streets since 1831, and the current building was completed in 1876. (Courtesy of Portsmouth Public Library.)

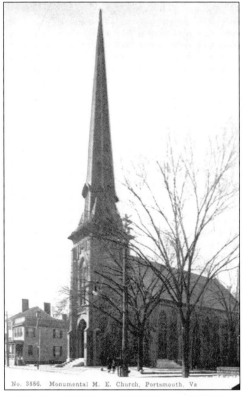

No. 3886. Monumental M. E. Church, Portsmouth, Va

POST OFFICE AND FEDERAL BUILDING, PORTSMOUTH, VA.

After the post office was moved to Crawford Street in 1961, this 1909 structure was converted to a new use as the main branch of the Portsmouth Public Library. Its Wilson Room, named for Esther Murdaugh Wilson, who served from 1914 to 1940 as the city's first public librarian, holds many rare materials that help in the study of genealogy as well as of state and local history. (Courtesy of Portsmouth Public Library.)

SEABOARD MARKET AND ARMORY, PORTSMOUTH, VA.

The Seaboard Market and Armory looked much like a castle when the Seaboard Air Line Railroad donated it to the city in 1893. It stood at the northwest corner of Crawford and South Streets until a modern armory was built on Elm Avenue in 1945. (Courtesy of Portsmouth Public Library.)

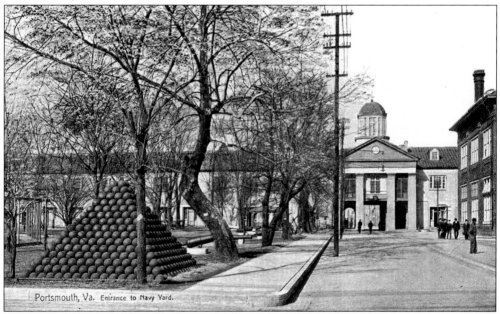

Portsmouth, Va. Entrance to Navy Yard.

There are still cannon and military mementos on display in the shipyard's Trophy Park, but security considerations now make these off limits to visitors. Once known as "Gosport Navy Yard," named "Norfolk Navy Yard" in 1929, and renamed " Norfolk Naval Shipyard" in 1945, the shipyard's name prevents many people from realizing that it is located in Portsmouth, Virginia. (Courtesy of Portsmouth Public Library.)

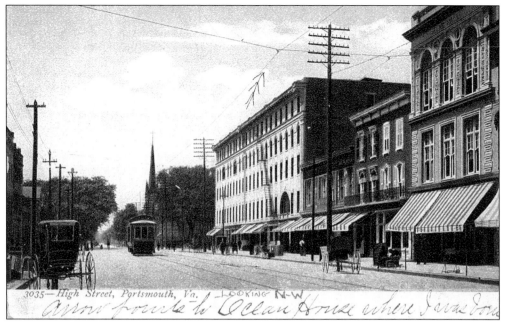

3035—High Street, Portsmouth, Va. ↙ LOOKING N-W

This nostalgic scene shows the northern side of High Street near Court Street. The block shown was designated as Oxford Square in William Crawford's 1752 plans for the city, and it was here that a large party was held to celebrate the city's 100th birthday in 1852. The building at the corner was the Ocean House Hotel, which was later renamed as the Monroe Hotel. (Courtesy of Portsmouth Public Library.)

After the Monroe Hotel was destroyed by fire in 1955, The Famous was erected on the northeast corner of High and Court Streets. Known for its up-to-date fashions and its beautiful bridal gowns, The Famous drew generations of women to downtown Portsmouth. Today, the structure serves as the fine arts campus of Tidewater Community College. (Courtesy of Portsmouth Public Library.)

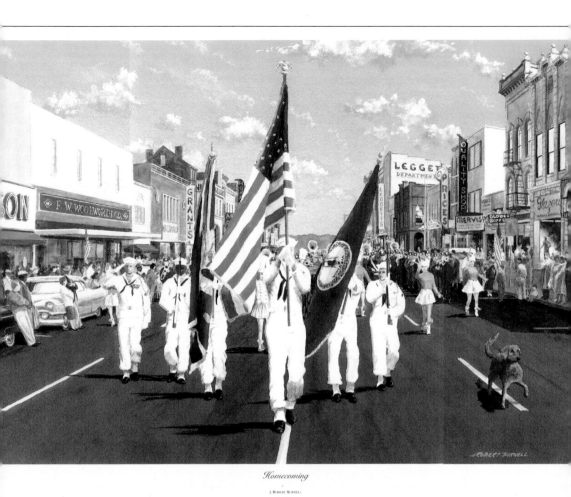

Homecoming

J. ROBERT BURNELL

A homecoming parade going west along High Street in the 1950s is captured in this print by J. Robert Burnell. It was commissioned especially for the city's 250th anniversary by the Portsmouth Partnership, a non-profit corporation that promotes the city. With its centuries of experience, Portsmouth continues to evolve as a port city with an important role to play in the nation and as a wonderful place to live or visit. Come see us soon! (Courtesy of The Portsmouth Partnership.)